# MYSTIC ANIMALS

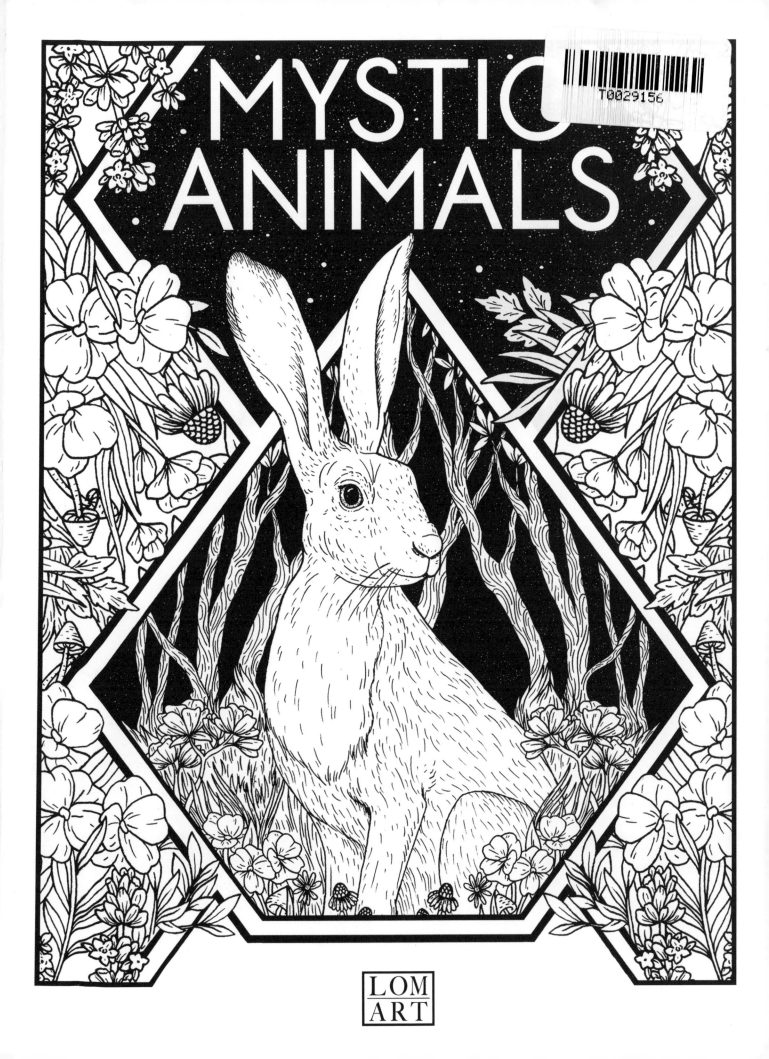

LOM ART

Illustrated by
Stratten Peterson

Written and edited by Lara Murphy
Designed by Jade Moore
Cover designed by Angie Allison

First published in Great Britain in 2022 by LOM ART,
an imprint of Michael O'Mara Books Limited,
9 Lion Yard, Tremadoc Road, London SW4 7NQ

W  www.mombooks.com/lom
f  Michael O'Mara Books
𝕏  @OMaraBooks
◙  @lomartbooks

A CIP catalogue record for this book is available from the British Library.

ISBN: 978-1-912785-73-5

1 3 5 7 9 10 8 6 4 2

This book was printed in China.

FSC
www.fsc.org
MIX
Paper from
responsible sources
FSC® C020056

# Introduction

Having lived alongside animals since the beginning of human history, it's no wonder that our stories are interwoven in myths, legends and cultural traditions from all around the world.

The detailed pictures in this book show animals surrounded by natural elements that reflect their symbolism and energy. From the tiny, joyful hummingbird to the gentle, mighty whale, the unique character of the animals that we feel akin to is revealed, and the light this throws on our own personality, behaviour, hopes and dreams is explored.

Awaken the ancient magic of the animals and let intuition lead as you complete your companion creatures.

# The Stag

With acute senses, the stag is associated with insight, wisdom and perceptiveness. If you feel an affinity with this animal, you may be highly sensitive and have the ability to negotiate challenges with grace. At times, your high levels of empathy may leave you feeling overwhelmed, so be careful not to take on the burdens of others without thought and consideration.

Presiding over all types of woodland life, in Celtic lore these gentle creatures are depicted as guardians of the forest. At any hint of danger the stag is quick to flee, and so reminds us to trust our instincts. Keen intuition will guide us away from danger while allowing us to embrace the right opportunities when they come along.

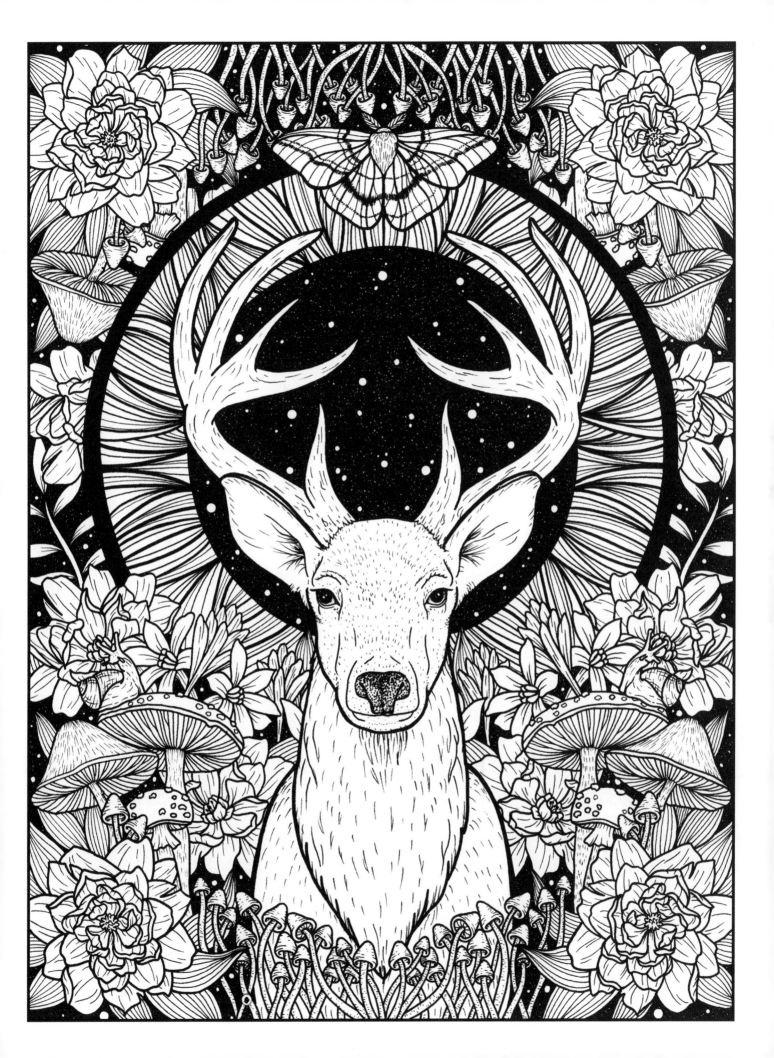

# The Fox

The cunning fox is a master problem solver. It is deeply attuned to the natural environment and quick to adapt to any situation. The fox can be glimpsed as a bold flash of red, travelling sure-footed through the night, or sensed as a secretive, slinking presence. It is supremely able to transition gracefully between the two. Those who feel a connection to the fox may have a similarly adaptable and resourceful spirit.

No matter what character the fox displays, it has a constant and steady sense of self. This canny creature serves as a reminder that while the world may ask you to blend in, your true spirit will always be your most valuable asset.

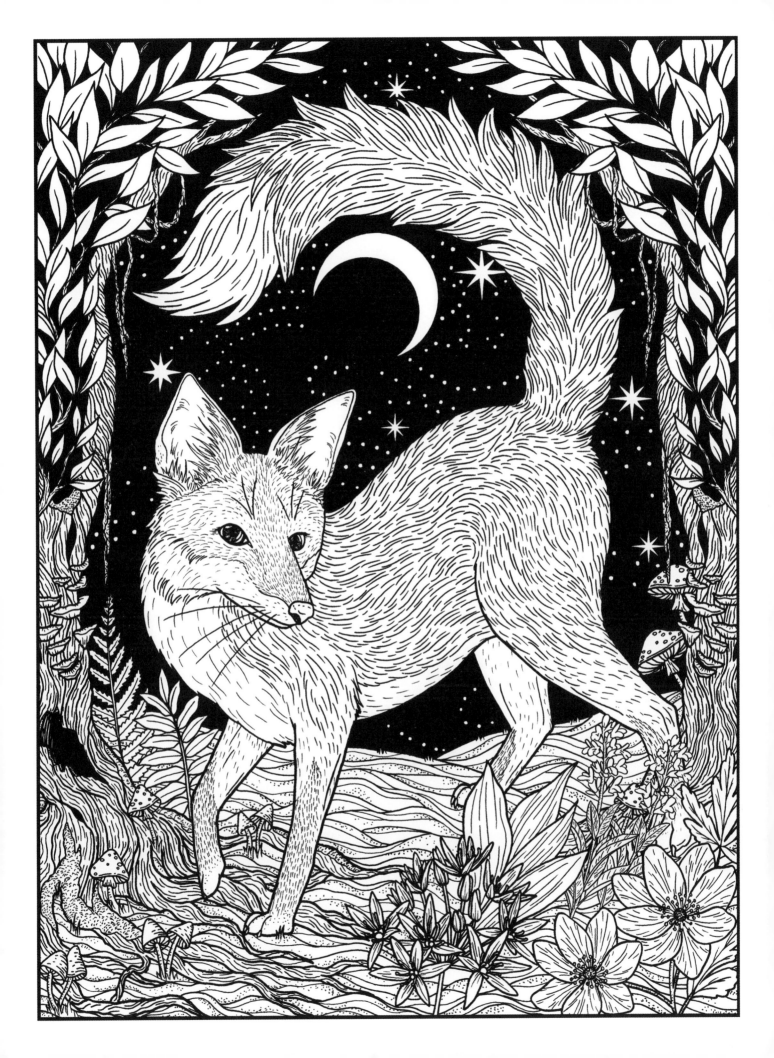

# The Bear

The bear is a symbol of courage, strength and protection.
It knows when a battle is worth the fight and when it's time to
take some respite. Following the bear's lead, we learn to reassess
our priorities and choose to pick our battles wisely.

These mighty creatures live in sync with nature, resting in winter,
before emerging with vitality in spring. They remind us to tap
in to nature's cycles and reconnect with our instincts.

The bear is a symbol of ferocious strength; a mother bear will
stop at nothing to protect her cubs. Those who feel an affinity
with the bear may be deeply protective of their loved ones
and feel empowered to stand up for what they believe.

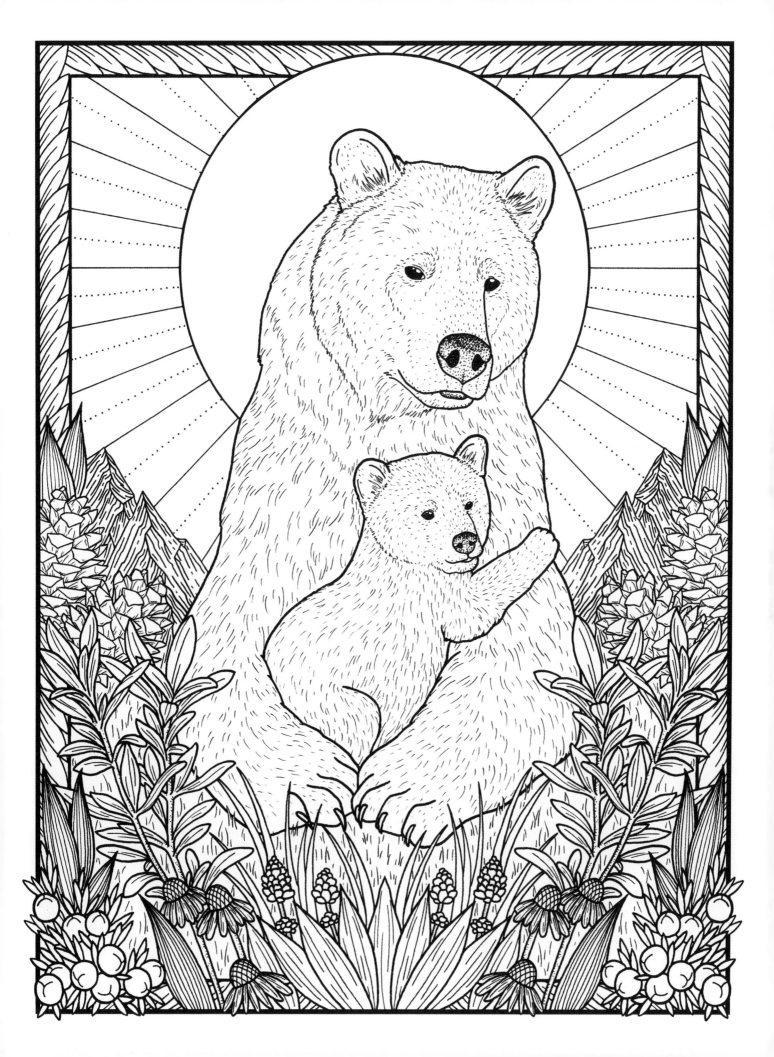

# The Bee

The bee is a busy little creature, driven by its internal compass.
Just as sunflower heads turn to track the Sun, bees follow their instincts
to find nectar, their precious bounty. If you connect with the bee, you may
have an ability to see the best in everything and everyone. The bee reminds
us that there's always joy to be found, if we know how to look for it.

Many bees build their hives cooperatively and efficiently, creating beautiful,
organized structures. They are strongest as a community; a good patch of
pollen is always shared with the hive. The bee serves as a reminder that
creating order among the chaos of life can be a powerful tool.

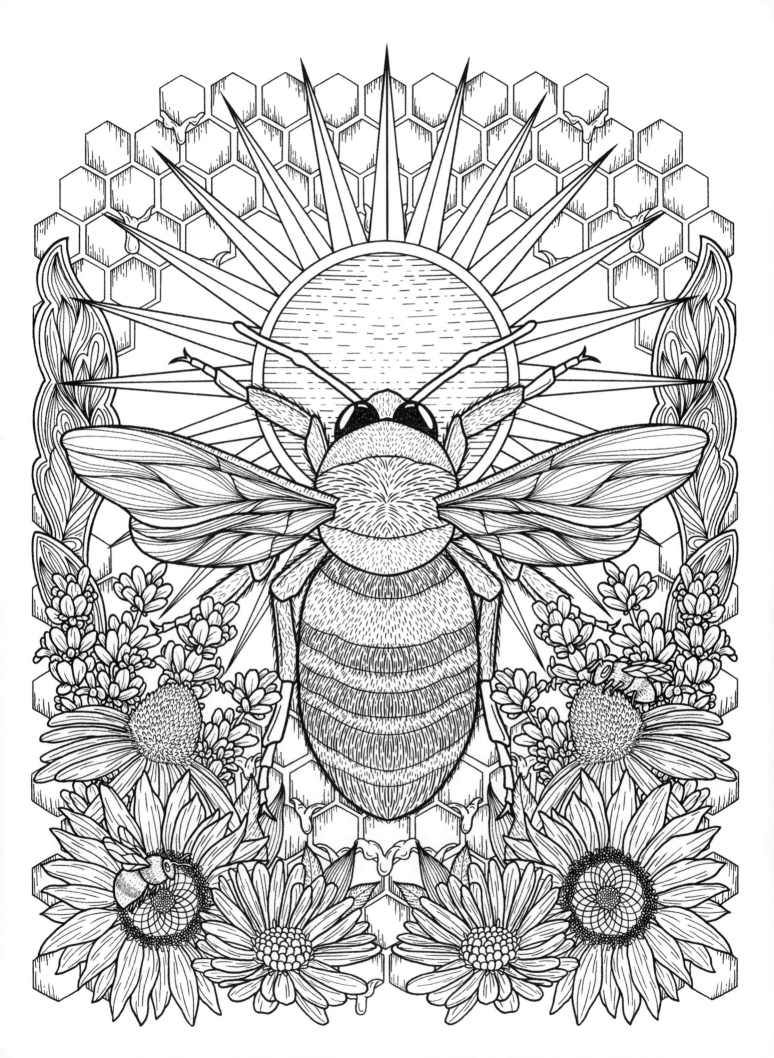

# The Cat

Those attuned to the mystical side of life may be drawn to the enchanting energy of the cat. The ancient Egyptians associated the cat with both the power of the Sun and the waxing and waning of the Moon. Just as the four-leaf clover is a well-known lucky charm, so the black cat is considered by many cultures to be a harbinger of good fortune.

This cunning creature knows how to get what it wants, moving with intent and self-assurance. Much like their big-cat cousins, cats lead without needing validation; their confidence is alluring. The cat serves as a reminder of your own self-worth and the right to live as you please.

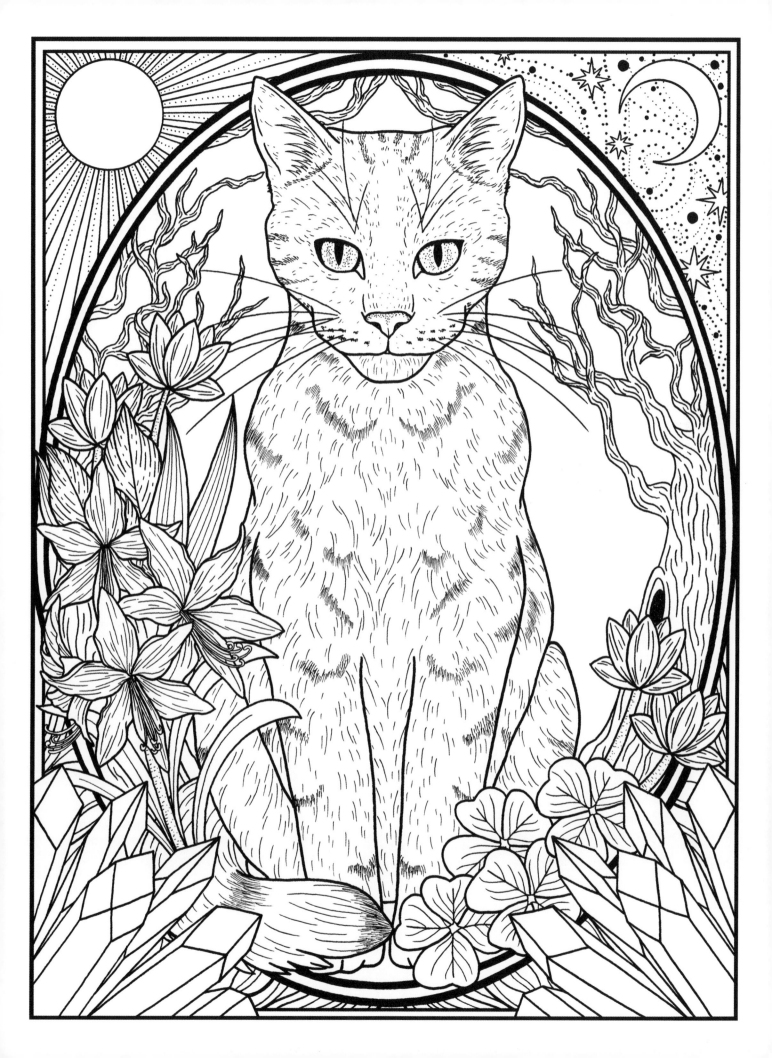

# The Ram

With majestic horns and a tough, wiry coat, this hardy creature
is never afraid to leap into challenging situations. The ram is
a symbol of bold leadership and unflinching self-belief.

At home on rocky cliffs and sheer mountainsides, the ram is adept at
negotiating life's obstacles and forging its own path. Taking its lead, we
are encouraged to embrace new opportunities and face adversity with
agility and courage. Rather than living within our comfort zone, the ram
symbolizes taking a leap of faith; good things happen to those who dare.

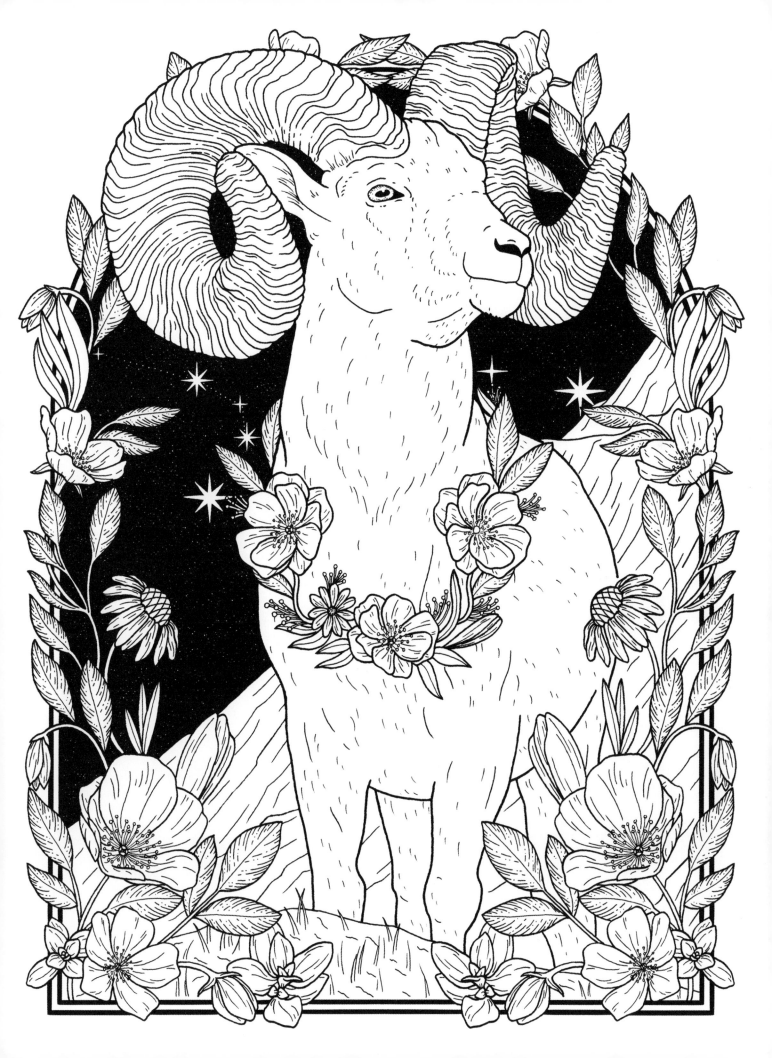

# The Parrot

If the spirited character of the parrot calls to you, you may have a natural charisma that puts you in the spotlight – a place where you thrive. The parrot prompts us to maintain a cheerful outlook on life and revel in creative endeavours that spark joy. It is highly intelligent and rarely passes up an opportunity to express itself. The parrot's bold disposition reminds us of the need to reveal our true selves with honesty and courage.

When life feels overwhelming, we can take the parrot's lead and embrace the day with a sense of openness and fun. Are there areas of your life you could approach with a lighter heart?

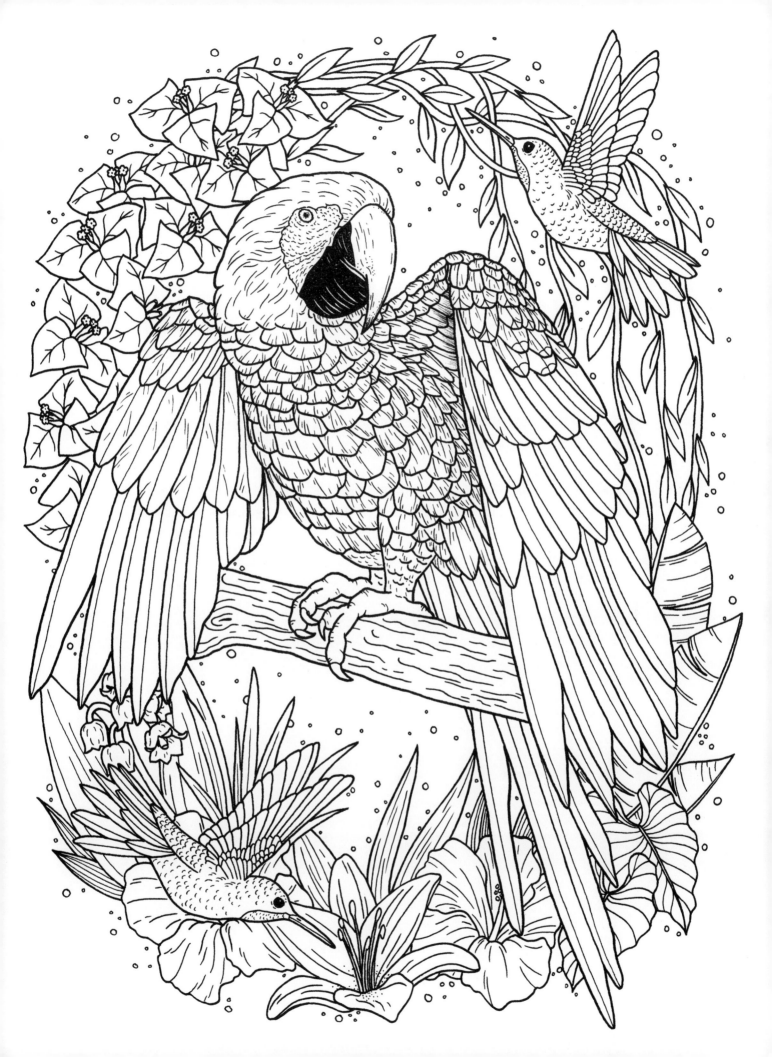

# The Otter

The otter has an inner fire that feeds its sense of curiosity, playfulness and adventure. Always in motion, the otter moves effortlessly from water to land, and can be seen as a symbol of drive and adaptability.

If you find it too easy to dwell on the bad, the otter acts as a reminder to accept life as it comes rather than fighting against the current. Achieving balance is the otter's way of life – balance between earth and water, and an equilibrium between work and play. When feeling out of kilter, a little otter-inspired mindfulness practice can help you to move past anything that doesn't serve you in order to embrace a more positive mindset.

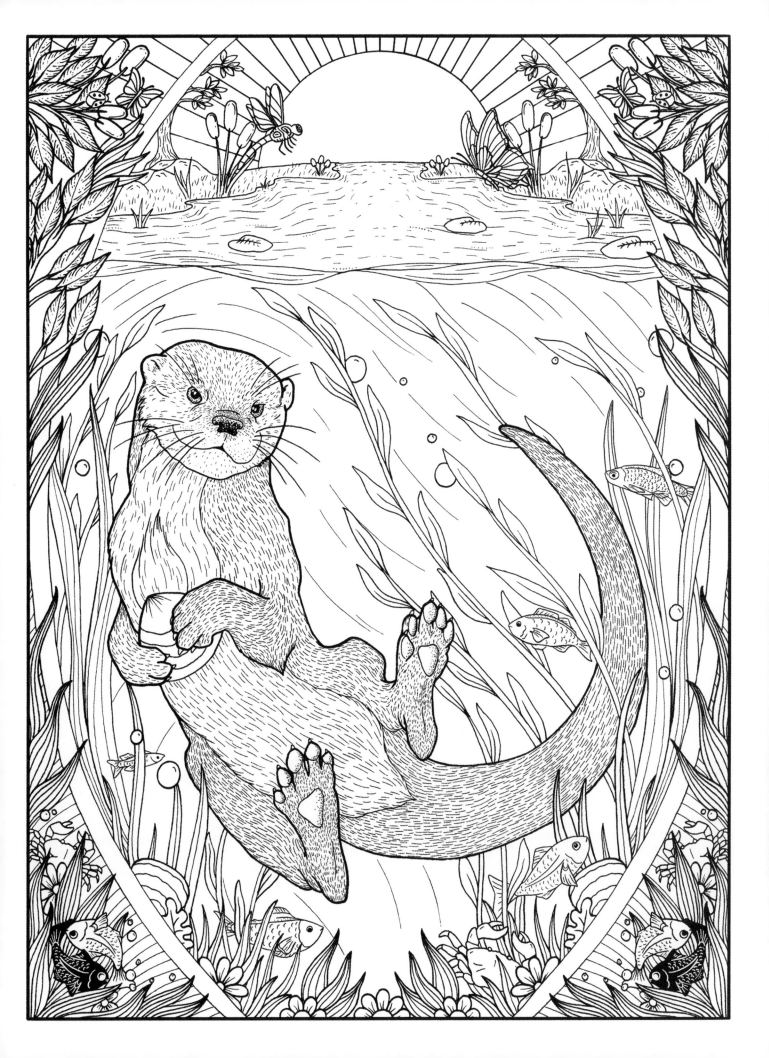

# The Tiger

The tiger brings together a striking combination of awe-inspiring beauty and terrifying power. As the largest wild cat, it is often depicted as the mighty king of the animal realm. Yet, it can also be seen peacefully watching the world go by, thus demonstrating the value of balancing strength with gentleness, dynamism with self-reflection.

At the age of two, the bold tiger cub strikes out on its own, living and hunting alone. Its courageous approach to life and ability to think for itself encourage us to carve our own unique paths through life. Those who believe in themselves give others the confidence to believe in them, too.

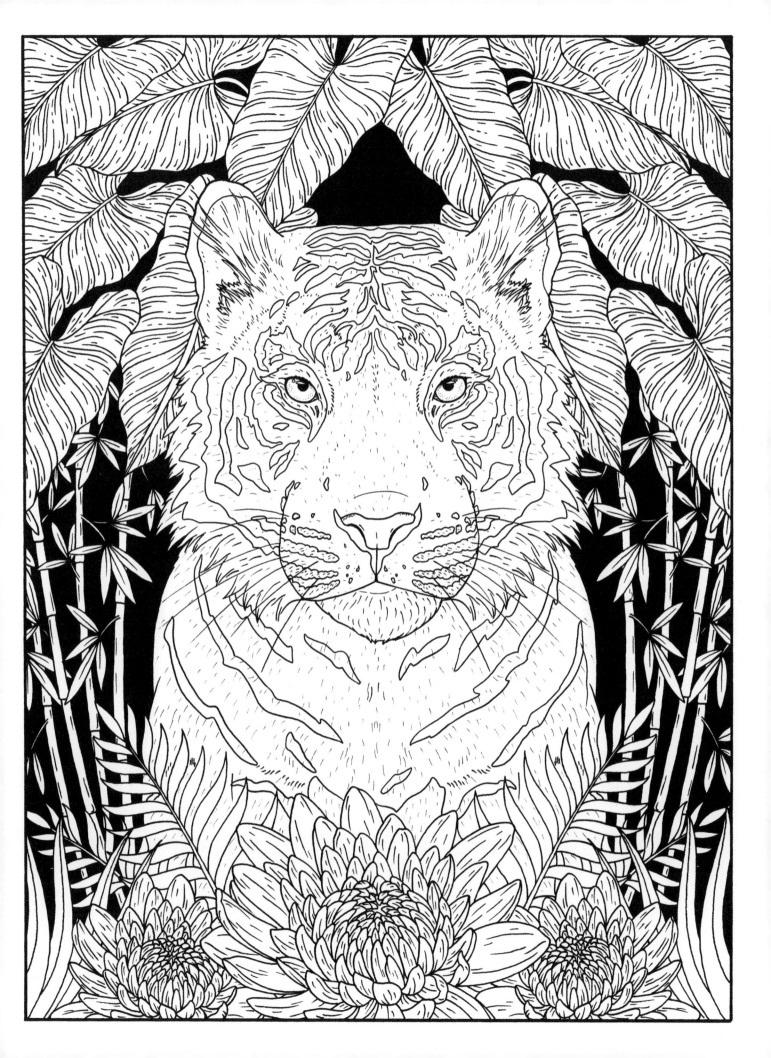

# The Chameleon

The chameleon is a master of disguise, ready to adapt to any situation in the blink of an eye. Those with chameleon traits may be highly creative with an openness to new ways of thinking – an invaluable strength.

If you feel an affinity with the chameleon, you may be quick to adapt to the people and situations around you. At times, you may feel more comfortable blending into the background – but are you just biding your time? When the moment is right, the chameleon steps outside its comfort zone and lets its true nature shine.

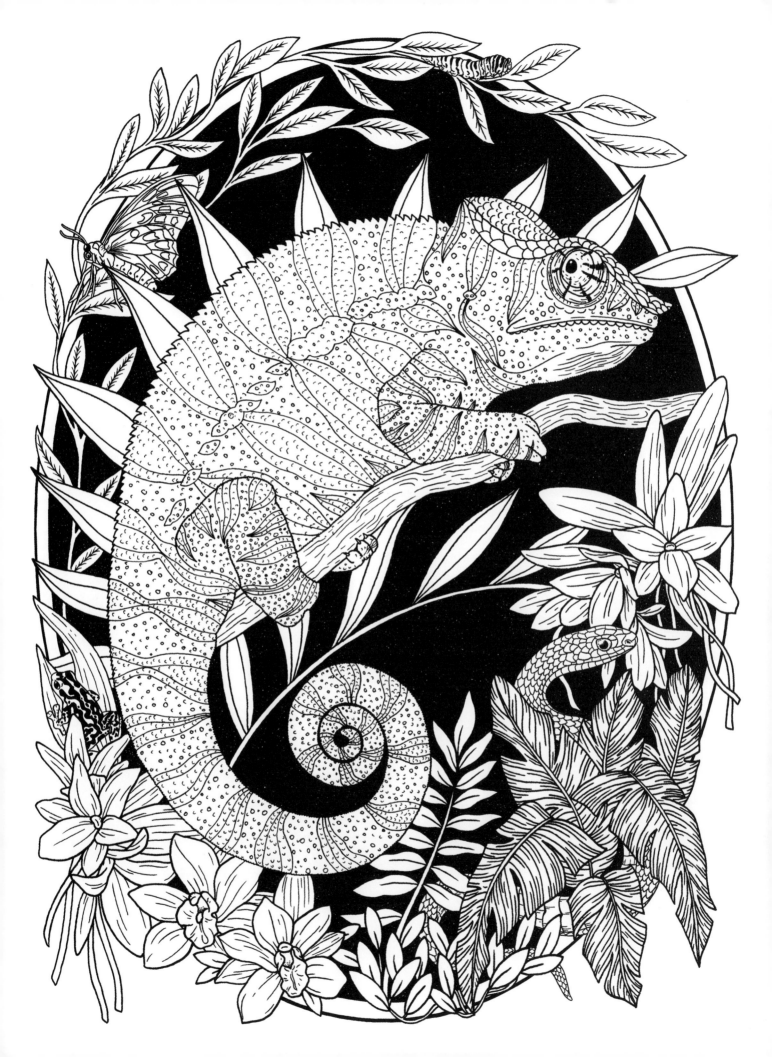

# The Lemur

Nocturnal lemurs jump like ghosts in the night through the forests of Madagascar, giving them a supernatural reputation. With acute senses and keen natural instincts, lemurs detect approaching danger. They remind us to trust our gut feelings when something doesn't seem right.

At the same time, fun-loving lemurs don't take life too seriously, their playful antics showing that laughter is the best tonic. Talented communicators, they are able to use their voices in a variety of ways, demonstrating the importance of delivery in conveying a message. The lemur shows us that our ability to connect with others is largely down to how comfortable we feel within ourselves.

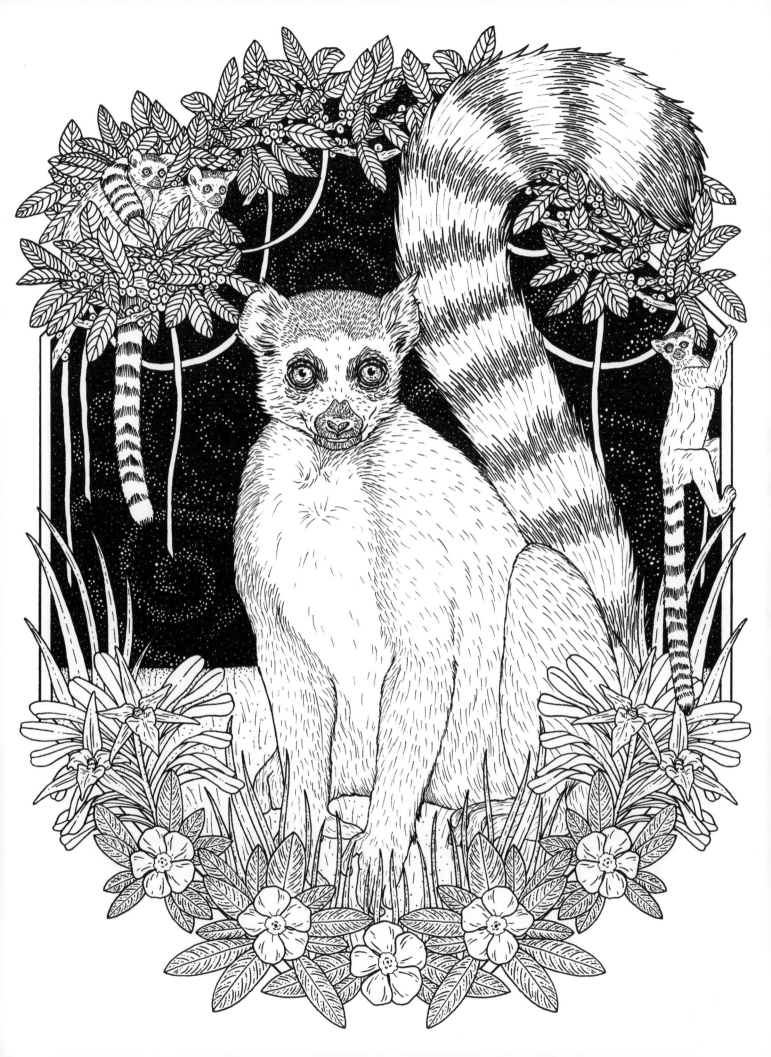

# The Horse

In Greek mythology, the divine horse Pegasus acts as a guide, helping people to discover and pursue hidden talents. With keen senses, the horse follows its nose to find water and shelters in a group when it detects an oncoming storm. It reminds us to listen to our inner wisdom.

The horse is emblematic of freedom, independence and a sense of adventure. Those drawn to its wild spirit may be driven to explore new places and start new ventures. Although generally peaceful animals, horses will not back down in a confrontation. This trait prompts us to persevere with important projects with courage.

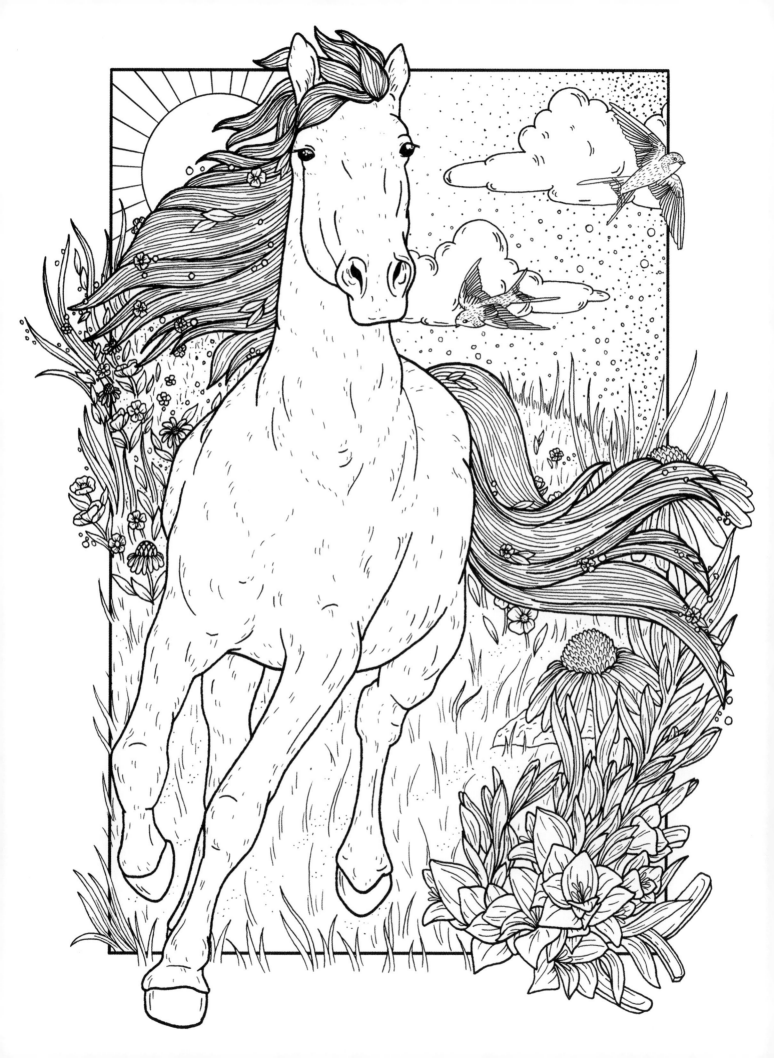

# The Hummingbird

The sunny disposition of the hummingbird is contagious; is it possible to look at a hummingbird without feeling its joy? This enchanting creature reminds us to take note of even the smallest moments of happiness. In challenging times, it is a symbol of brighter days ahead.

The hummingbird may be small but it is a tireless lifeforce. It can fly backwards, beat its wings up to 80 times per second and has a special skill: it can wave its wings in a figure-of-eight pattern – the ancient symbol of eternity. If you feel drawn to the hummingbird, you may be known for sharing your resolute energy, optimism and creativity with others.

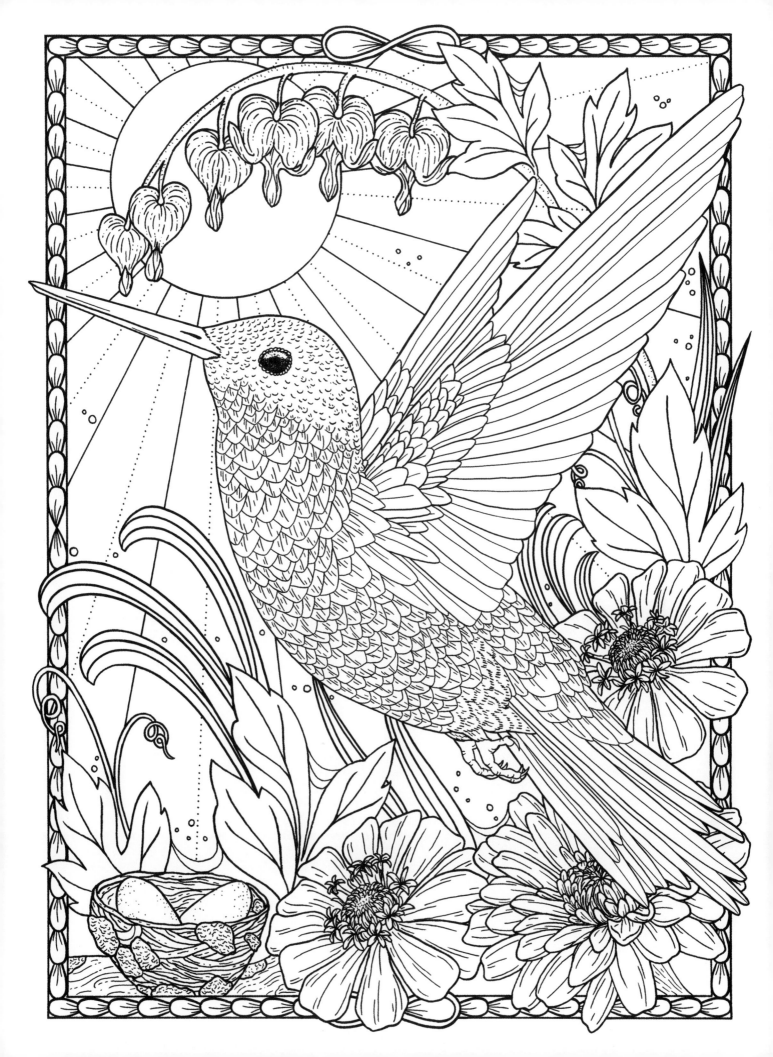

# The Snake

Spending its life close to the ground, the snake is thought to be in tune with the subtle vibrations of the Earth. It symbolizes grounding energy and reconnecting to the here and now.

Shedding its skin several times a year, the snake is a literal example of the value in leaving behind the past in order to move forward. Like the death's head moth and chrysanthemum flower, both symbols of rebirth, the snake demonstrates that, whatever happens, we have the power to choose our own path, even if it means starting again from scratch.

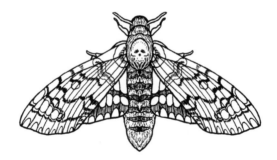

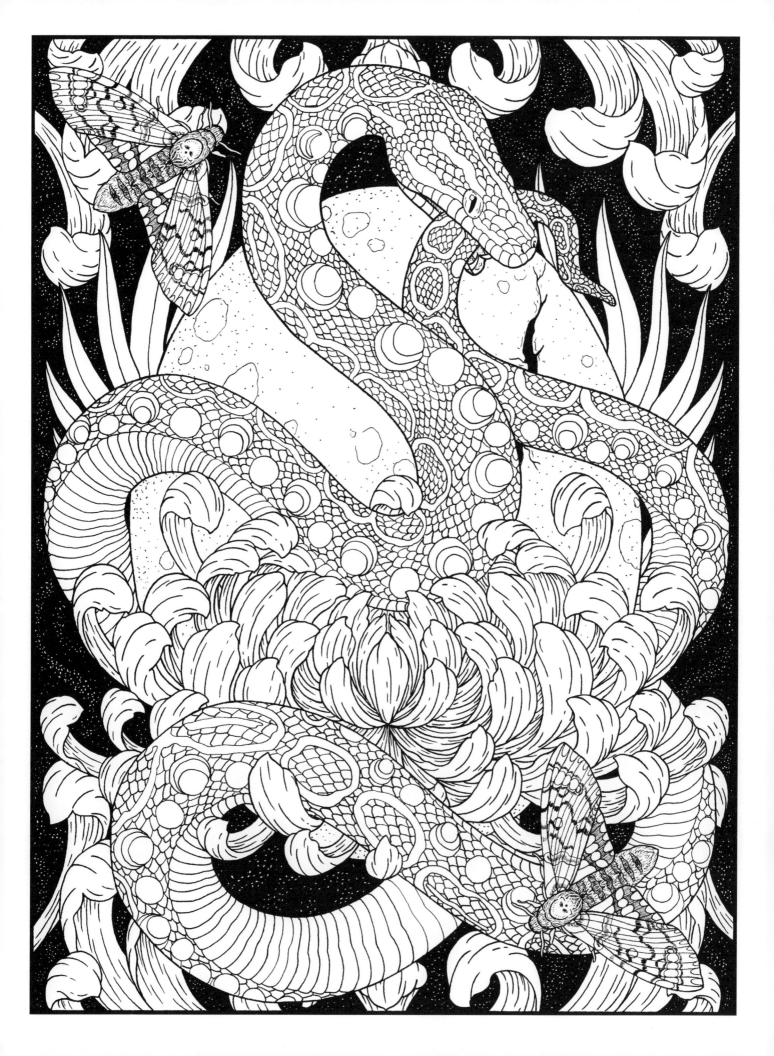

# The Frog

With their ability to lay thousands of eggs at a time, frogs are commonly associated with fertility, feminine energy and nurturing qualities. In ancient Egypt, the frog was a symbol of new life as they arrived in droves when the River Nile flooded and thirsty crops were nourished. If you identify with the frog, you may notice opportunities that others miss, allowing people and projects to flourish under your care.

Depicted here alongside Green Aventurine, the 'stone of opportunity', the frog easily adapts to its environment, moving fluidly between water and land. If you're undergoing a period of transition, the frog serves as a reminder that with change comes new opportunities and that something amazing may be waiting just around the corner.

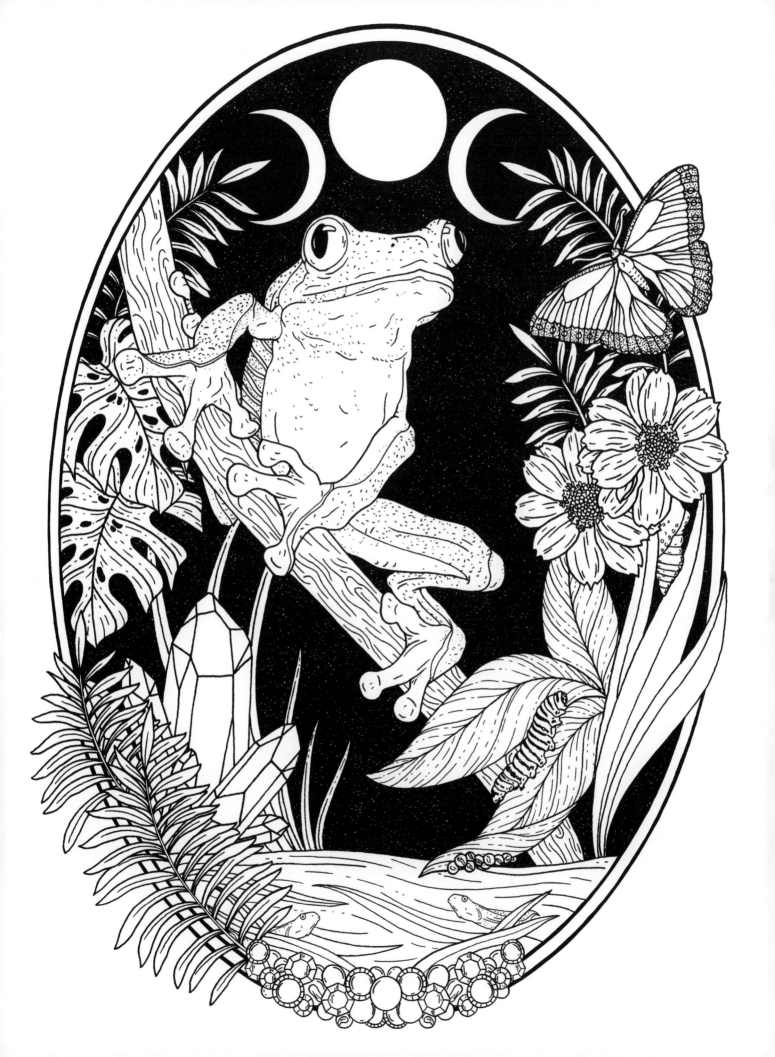

# The Heron

With serene patience, the heron stalks shallow waters, waiting for
an opportune moment to pluck a bite to eat. Its attitude reminds
us of the importance of acting with focus and attention. The heron
knows what it wants and acts without doubting itself.

In ancient Egyptian mythology, the god Bennu takes the form of a heron
and is associated with the creation of the world. The heron is symbolic of
new beginnings, regeneration and growth. It calls upon us to enquire deep
within ourselves to find direction – only then can we act on opportunities
with the self-belief of this cool and collected hunter.

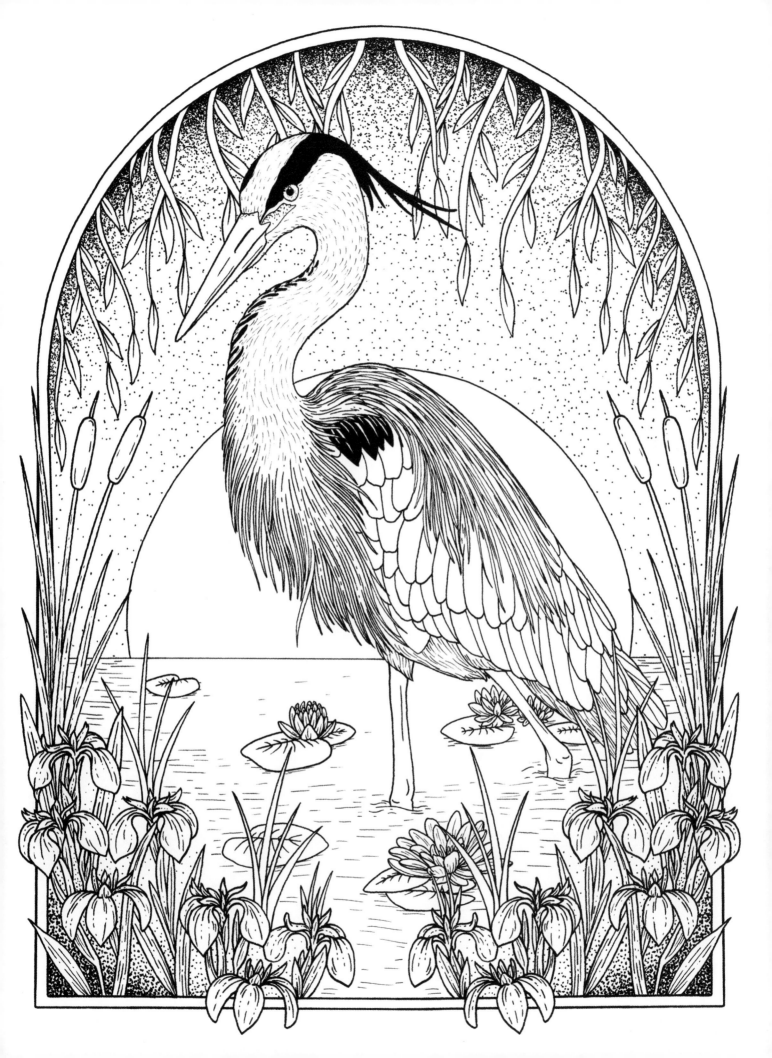

# The Lion

Since the Middle Ages, lions have been portrayed in myths and fairy tales as symbols of strength, power and status. Some of the earliest depictions are found in ancient Egypt, where the solar god Maahes took the form of a formidable lion. Those drawn to the qualities of the lion may be natural leaders, accepting the respect of others with humility and grace.

If you feel in need of a little 'lion energy', this majestic creature is a reminder that you have the inner strength and intuition needed to rise to the challenges you face. Let your true voice – your lion's roar – be heard.

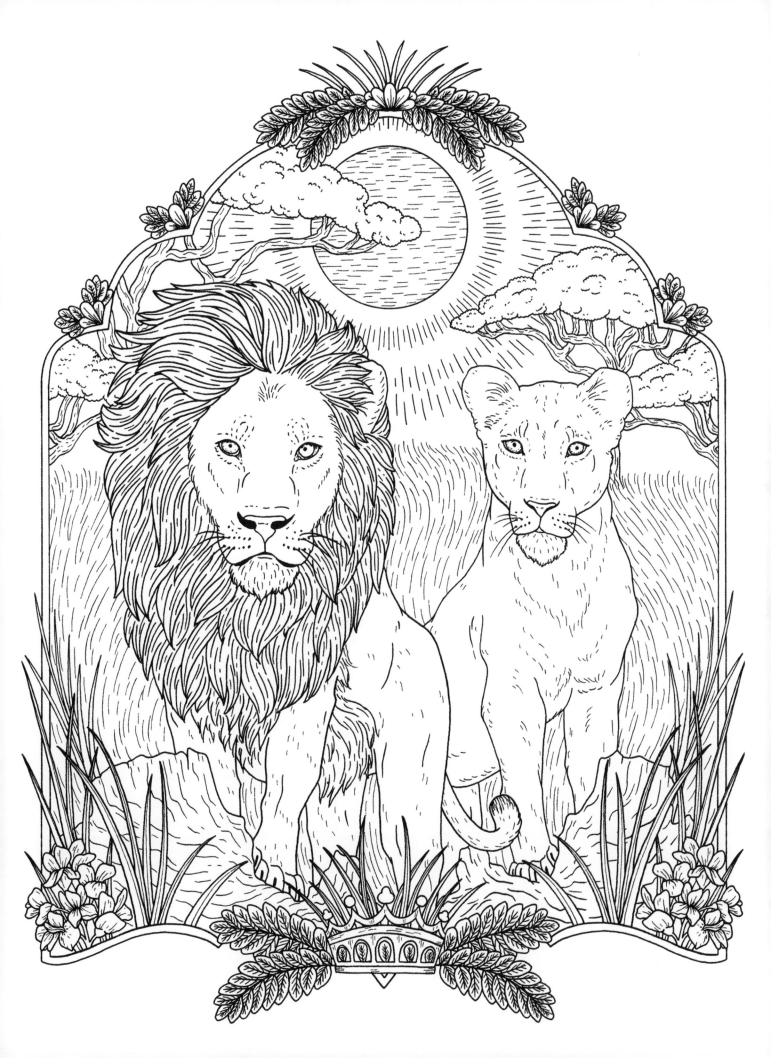

# The Monkey

The monkey knows how to live joyously. It is an intelligent, curious and cheeky character that takes every moment as it comes. Those who feel drawn to the monkey may be caring and sociable, and have a large group of friends. They may also be good problem solvers who are always on hand with an imaginative solution.

The monkey encourages us to invite more playfulness into our lives. If you're clinging on to a serious or negative outlook, the monkey is a symbol of embracing a lighter attitude. Why not let go of self-imposed rules and invite a sense of curiosity and wonder into your life?

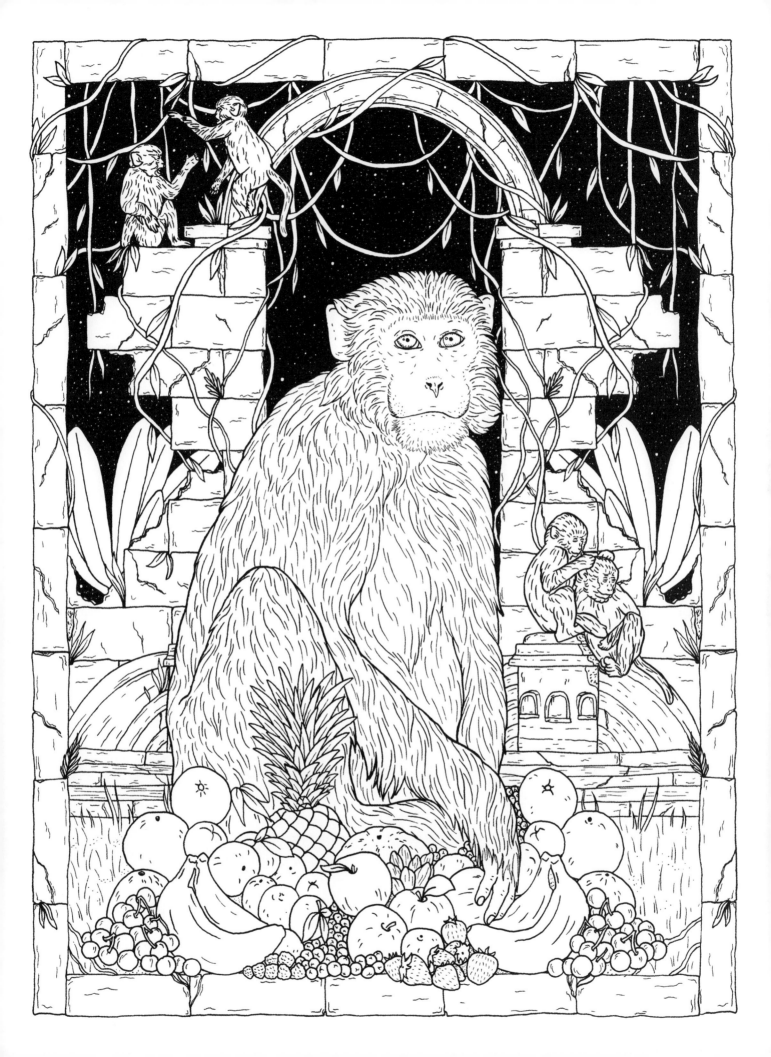

# The Sloth

With its slow-moving, considerate approach to life, the sloth can conserve energy and focus on its top priorities. Through channelling the spirit of this gentle creature, we can learn how to build emotional stability and resilience in our own lives. There's a lot to be said for slowing down.

With its surprising ability to view the world with an almost 270-degree rotation of its head, the sloth is a master of seeing alternative perspectives. Those who connect with the sloth may be observant and wise, but their calm, kind nature may prohibit their ability to challenge others' viewpoints. The sloth serves as a reminder that you have many worthy things to say.

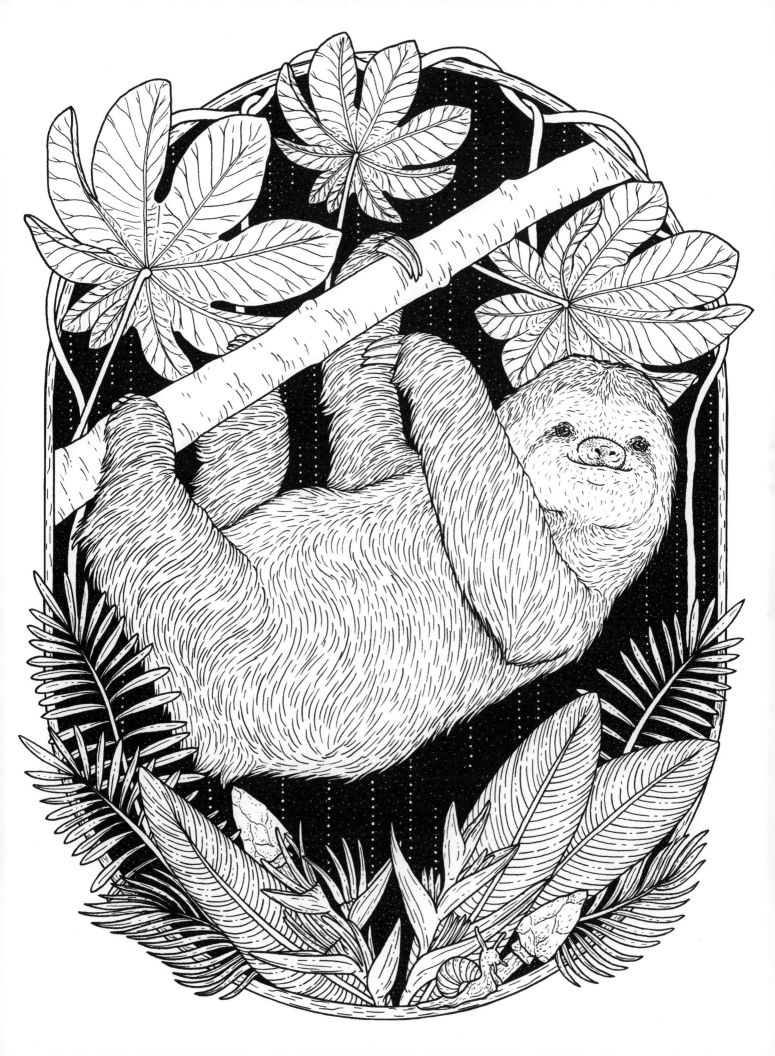

# The Butterfly

It's hard not to be in awe of the intricate designs captured on a butterfly's delicate wings. As residents of our planet for over 200 million years, the mystical butterfly has long been incorporated into mythology and folklore. In ancient Greece, the butterfly symbolized the soul; 'Psyche', meaning 'soul', is the name given to the Greek goddess with butterfly wings.

The butterfly is an emblem of beauty, freedom and transformation. As it undergoes metamorphosis, the butterfly welcomes radical change. For those who feel cocooned within their comfort zone, the butterfly encourages us to dream bigger and brighter, be curious and break the bonds of limiting beliefs.

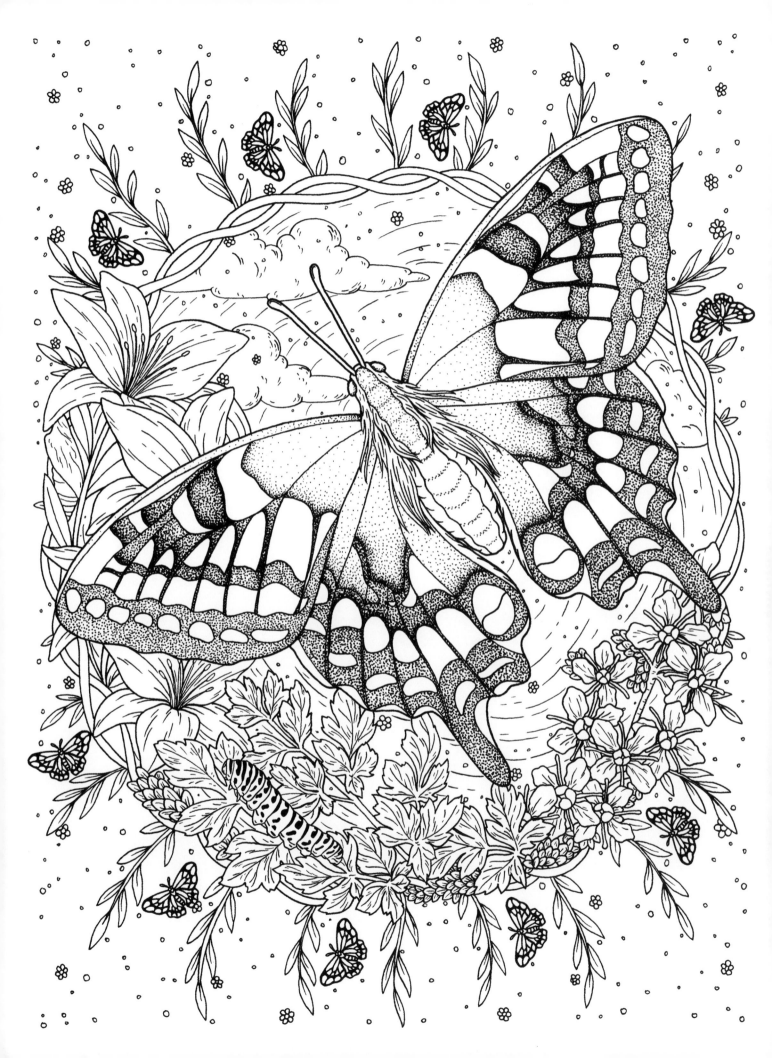

# The Hare

The hare is associated with changing seasons. In spring, athletic female hares are seen 'boxing' away tiresome males; their self-assured natures are a reminder to defend your personal boundaries. Renowned by hunters for being difficult to catch, this animal's ability to escape harm makes it a symbol of prosperity in many cultures.

Nesting in hollows in the ground or hidden by long grass, the hare is a creature of the earth. It roams free and trusts that nature will provide the shelter and sustenance it needs. For those experiencing stress or anxiety, the hare offers a comforting, grounding energy.

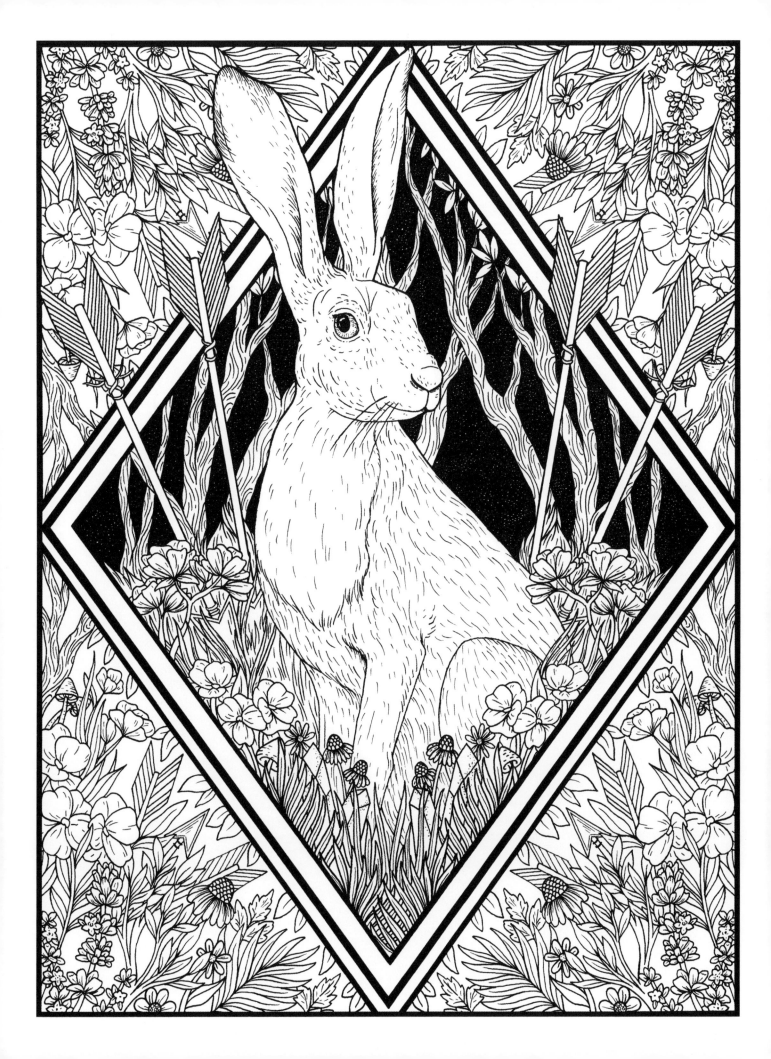

# The Owl

With its ability to see in the dark and turn its head in nearly every direction, the owl is associated with supernatural powers, wisdom and intuition. Those who feel an affinity with the owl may have the potential to see situations as they truly are and bring the truth to light.

As a creature that hunts alone and thinks for itself, the owl is a symbol of independence. Its ability to find its way in the dark provides inspiration to keep moving forward, even if the path ahead appears daunting or unclear.

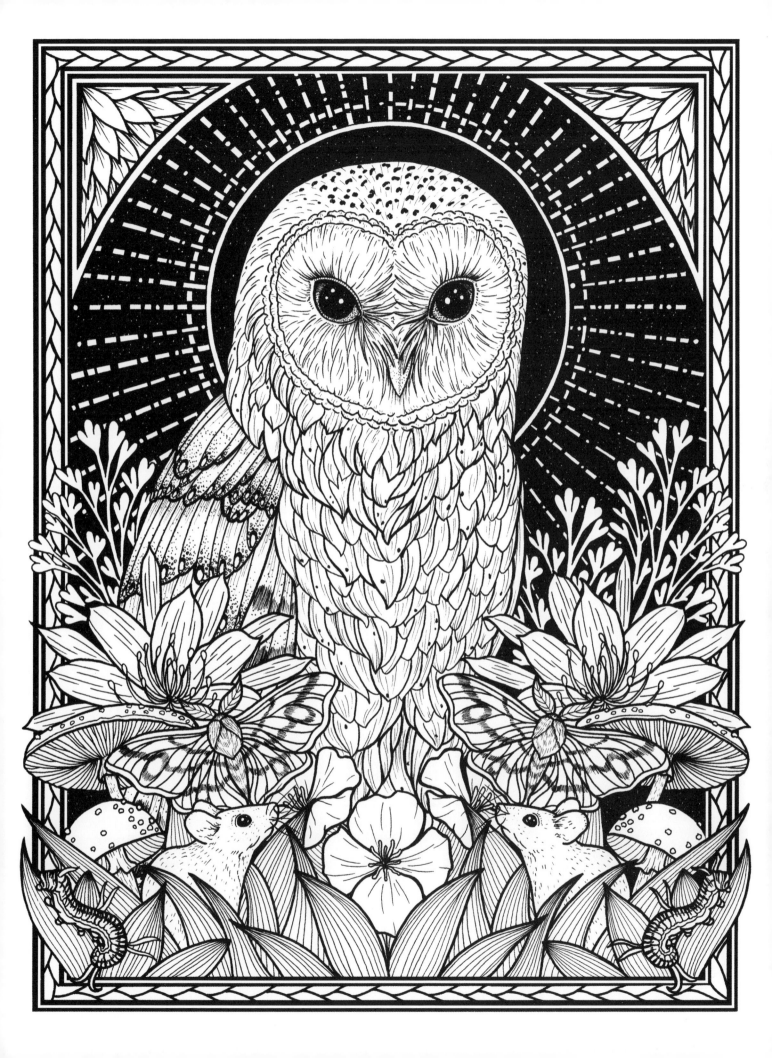

# The Koala

Taking time to consider the slow and gentle koala can instil a sense of calm. These homebodies find safety in their 'home trees' – a collection of trees where they live throughout their lives. They remind us of the importance of creating a stable, peaceful sanctuary, where we feel at ease.

The koala lives in the here and now, going with the flow of nature. If you connect with the koala, you may feel similarly laid-back, with an alluring ability to radiate feelings of safety and calm. For others, the koala serves as a reminder to slow down and prioritize their needs. Can you designate more time for rest, for nourishing meals and for activities that bring a sense of wellbeing?

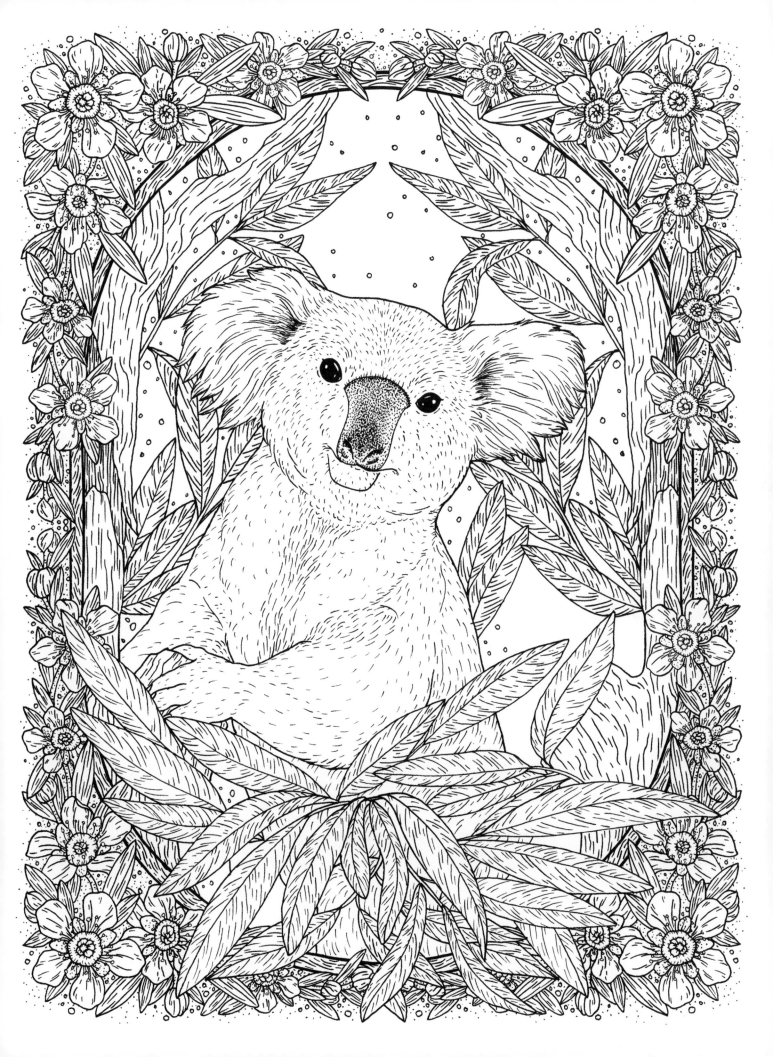

# The Seahorse

Even a glimpse of a seahorse is magical and mesmerizing. It features in ancient stories and legends, including pulling the chariot of the Roman god Neptune. Using its tail to latch on to sea plants, or on to the tail of its mate, the seahorse remains anchored when currents are strong. It is a symbol of strongly built foundations and resilience when the tides turn.

Those who feel an affinity with the seahorse may be highly empathetic, with the ability to build trusting relationships. Many species of seahorses are monogamous; pairs perform extravagant daily greetings and share parental responsibilities. They remind us that love endures if we take care of those closest to us.

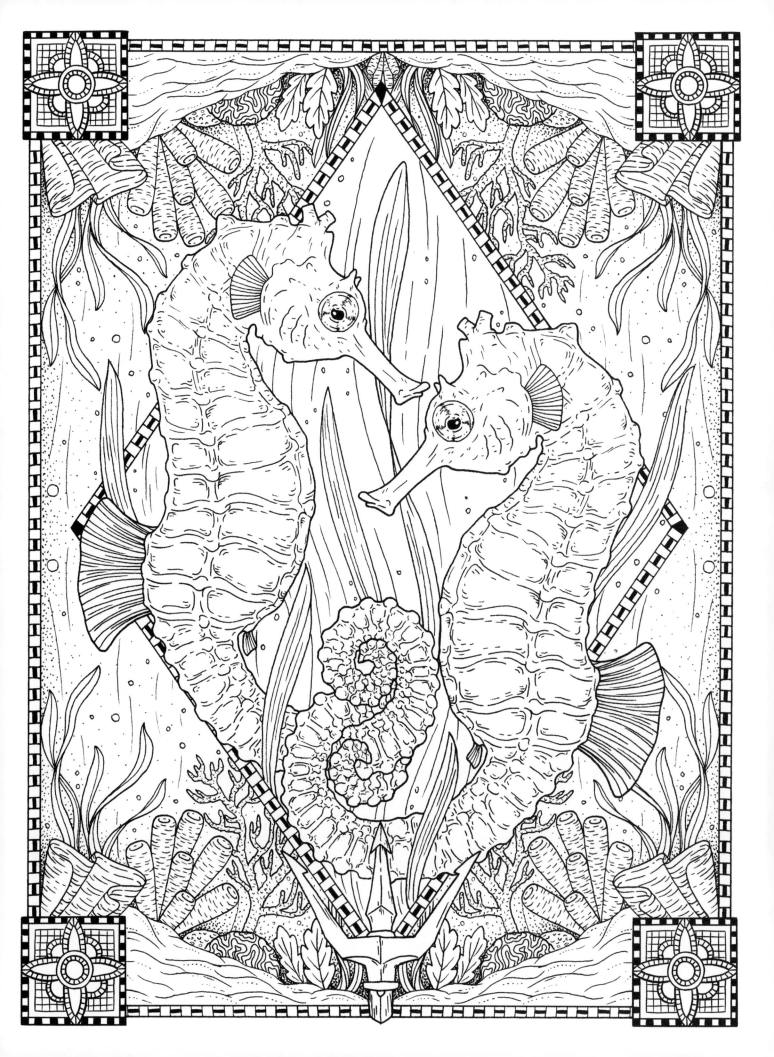

# The Bald Eagle

The bald eagle has become synonymous with freedom, courage
and possibility. It can soar high and roam as far as its heart desires.
It serves as a reminder to challenge your perceived limitations
and pursue projects that make your spirit soar.

Bald eagles mate for life, building a shared nest each year.
They remind us of the importance of creating strong and honest
foundations in our relationships. With powerful eyesight, the eagle
is said to have the gift of foresight. If you find yourself resonating
with this noble creature, you may have an ability to see the
bigger picture, gaining a bird's-eye perspective on life.

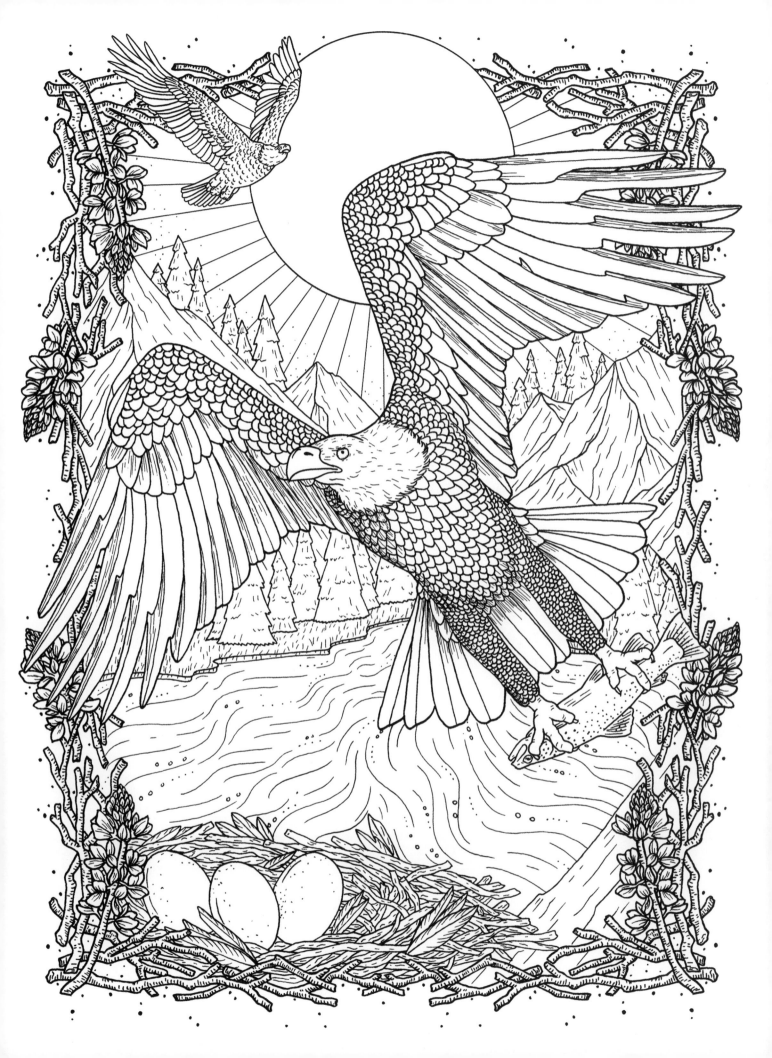

# The Wolf

It's in the wolf's wild nature to form deep bonds with its pack. In Roman mythology, the she-wolf is seen as a protector, caring for the twins Romulus and Remus. Similarly, in Celtic mythology, wolves are depicted as helpers and guides. If you connect with the wolf's character, you may be adept at understanding social dynamics.

The wolf encourages us to connect with people who give us strength. In a world that values individuality, it reminds us of the importance of working for the common good. With the support of a pack, we're able to step outside our comfort zone and welcome the growth this brings.

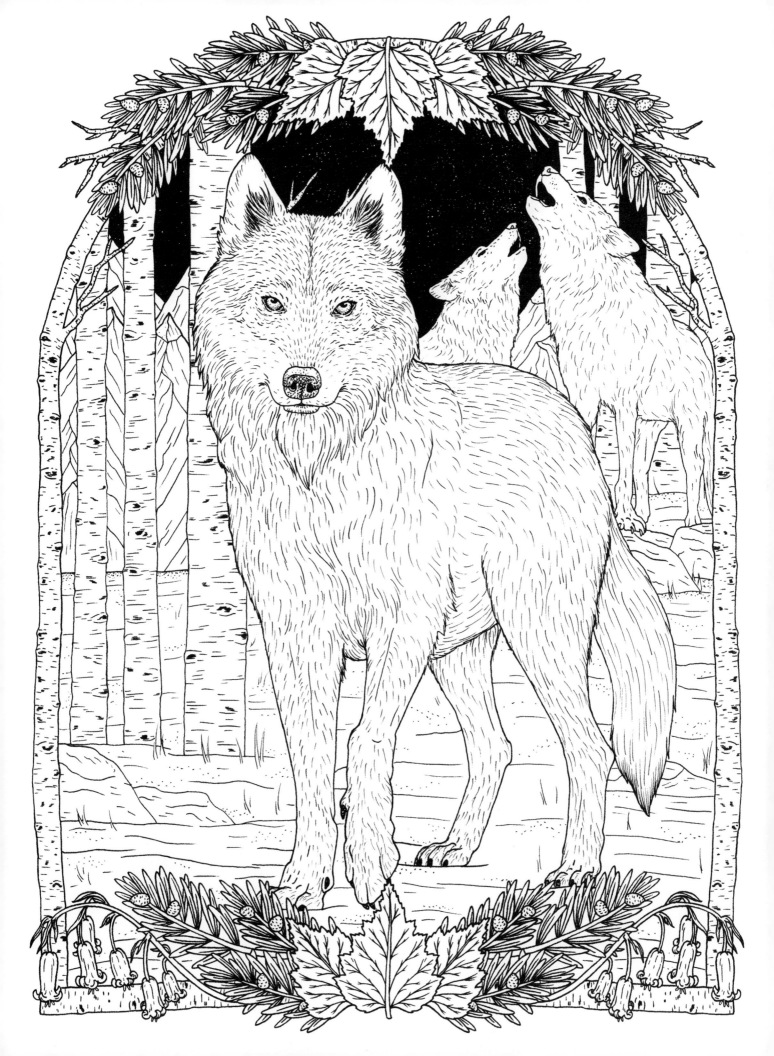

# The Woodpecker

Woodpeckers are among the smartest and most resourceful birds.
Like the oak trees in which they often reside, they are associated with
perseverance, as well as luck and prosperity. The ancient Greeks revered
the woodpecker as a symbol of new life and the cycles of nature.
Those who connect to this self-assured creature may be caring and
nurturing, with a gift for uncovering the true natures of others.

Tapping out its heartbeat-like tempo, the woodpecker reminds
us to tune into the natural rhythms of life and take note of the
patterns we live by. Ask yourself – which habits are serving
you well and which ones could you do without?

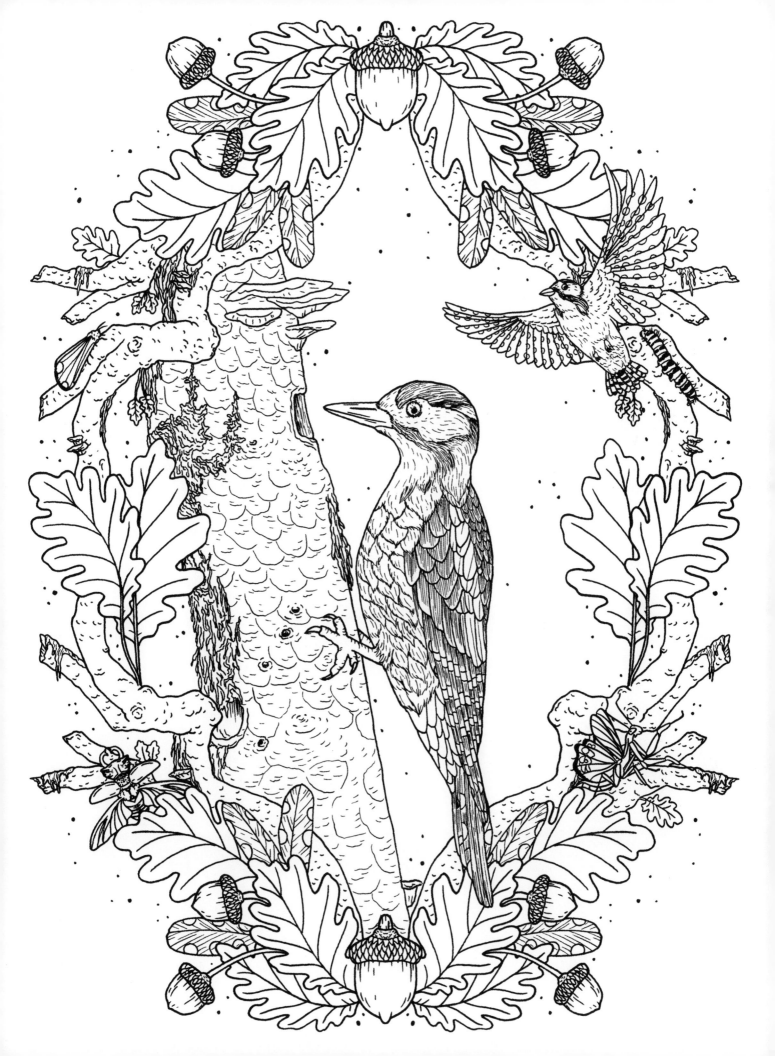

# The Rooster

The rooster's crow marks the dawn of a new day; time to embrace
a fresh start. Historically, the rooster has been a symbol of the Sun
and the warming safety of sunlight. As it stands vigilant and alert
against the sunrise, it's clear why the rooster is considered a
symbol of rebirth and courage.

Those drawn to the plucky character of the rooster may be practical,
confident and resourceful, with an admirable ability to focus on their priorities.
The rooster may inspire others to discover what motivates them, welcoming
more direction into their lives. We can learn from the rooster's fiery lust
for life and desire to make the most of every second of every day.

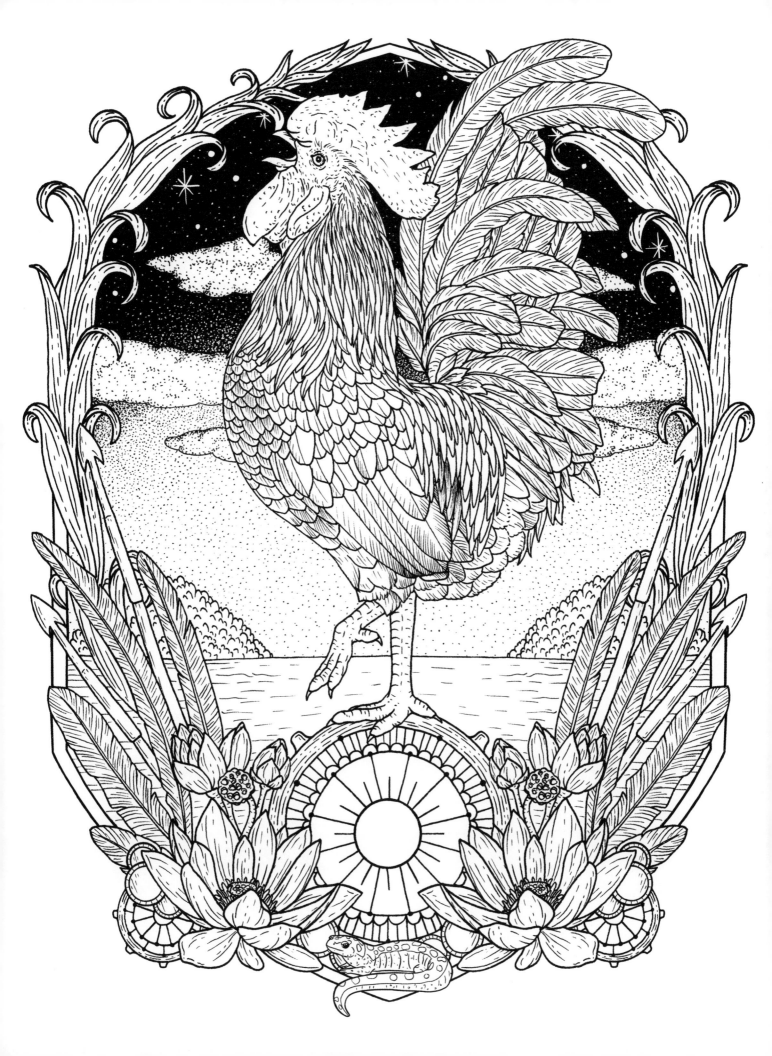

# The Giraffe

The giraffe is able to rise above situations, holding its head high and exuding a quiet, grounded confidence. Native to the African continent, giraffes are an integral part of African mythology and folklore. They are seen as spiritual animals, connecting Earth with the heavens above.

Taller than any other mammal, the giraffe enjoys the highest leaves and is a symbol of aspiration and achievement. As the first animal to see danger, it is said to have the gift of foresight and is a natural leader in the animal kingdom. With its head in the clouds and its feet on the ground, the giraffe reminds us to balance lofty dreams with substantive foundations.

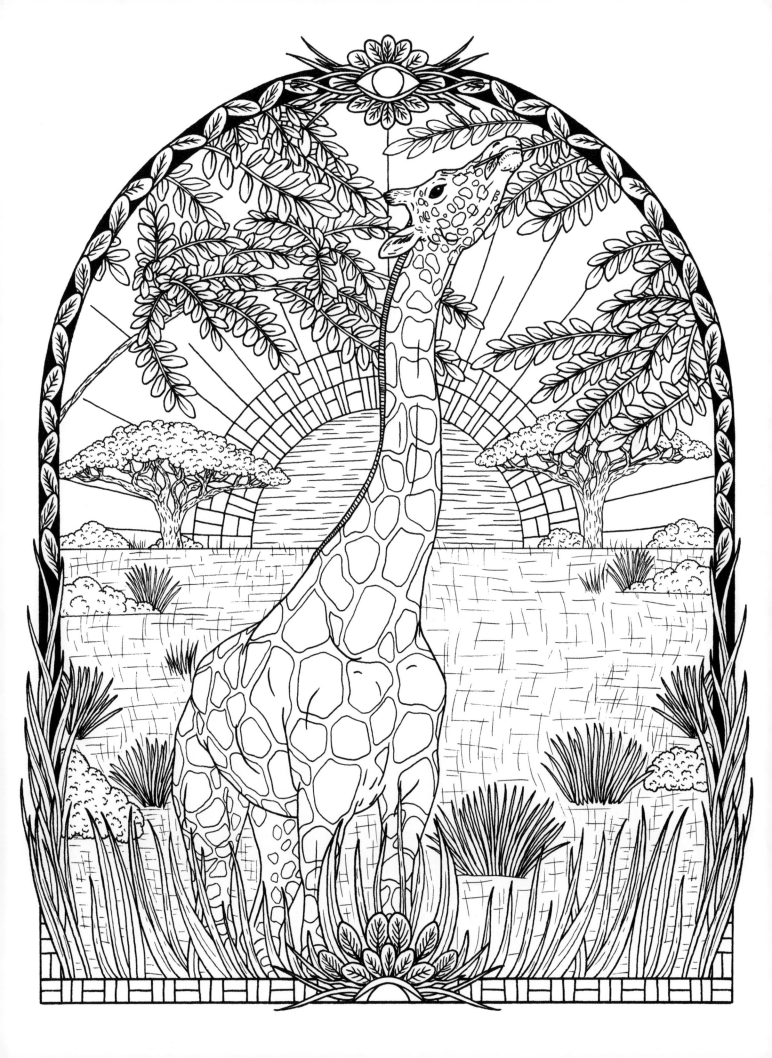

# The Dragonfly

It is thought that Celtic stories of fairies may have been inspired by the dancing, iridescent magic of dragonflies. With fragile, radiant wings, the dragonfly reminds us of the many miracles of nature.

Dragonflies begin as larvae in water, before transforming into beautiful winged creatures. Their metamorphosis is symbolic of hidden potential, innate wisdom and lifelong learning. Once in flight, a dragonfly's life is fleeting – it prompts us to squeeze the most out of every day. Those who feel an affinity with the dragonfly may be quick to adapt, moving through life with deftness and grace.

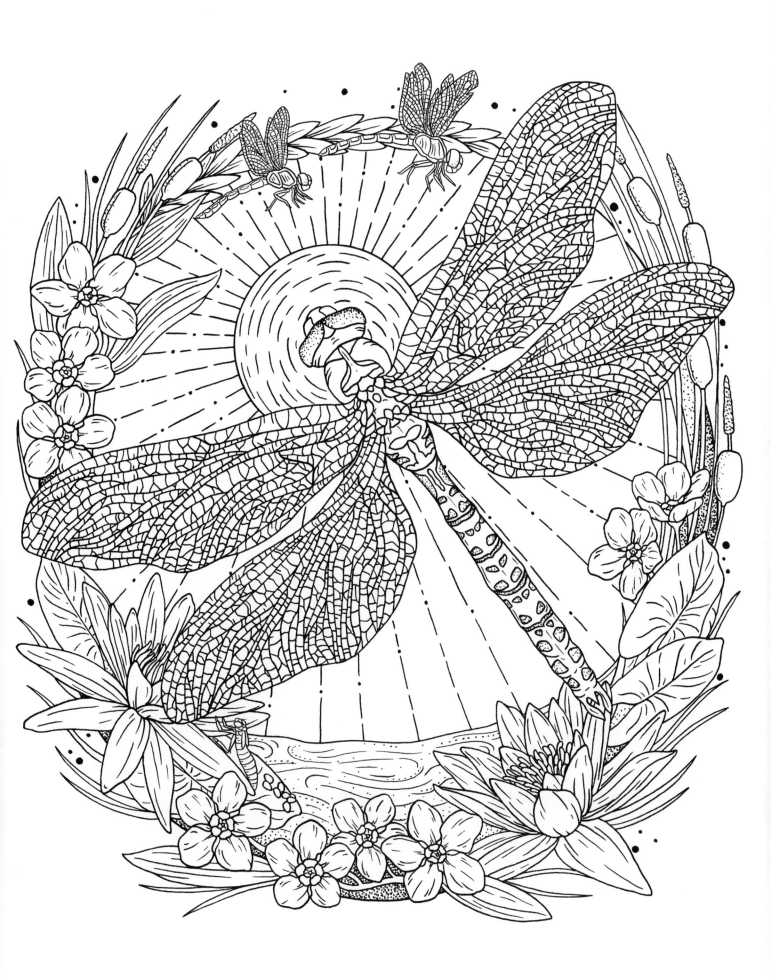

# The Whale

Among the largest animals in existence, the humpback whale is a
symbol of magnificence. This gentle giant has a calm, intelligent nature
and protective instincts. They are dedicated parents, going to heroic
lengths to raise their young to adulthood and thus set an example
to hold family and community in the highest regard.

Using sonar to explore the dark ocean depths, these majestic creatures
are in tune with all their senses. Whales are also excellent communicators,
using clicking and whistling sounds to talk and sing to one another.
Those drawn to the whale may be adept at reading social signals
and understanding people intuitively, even when nothing is said.

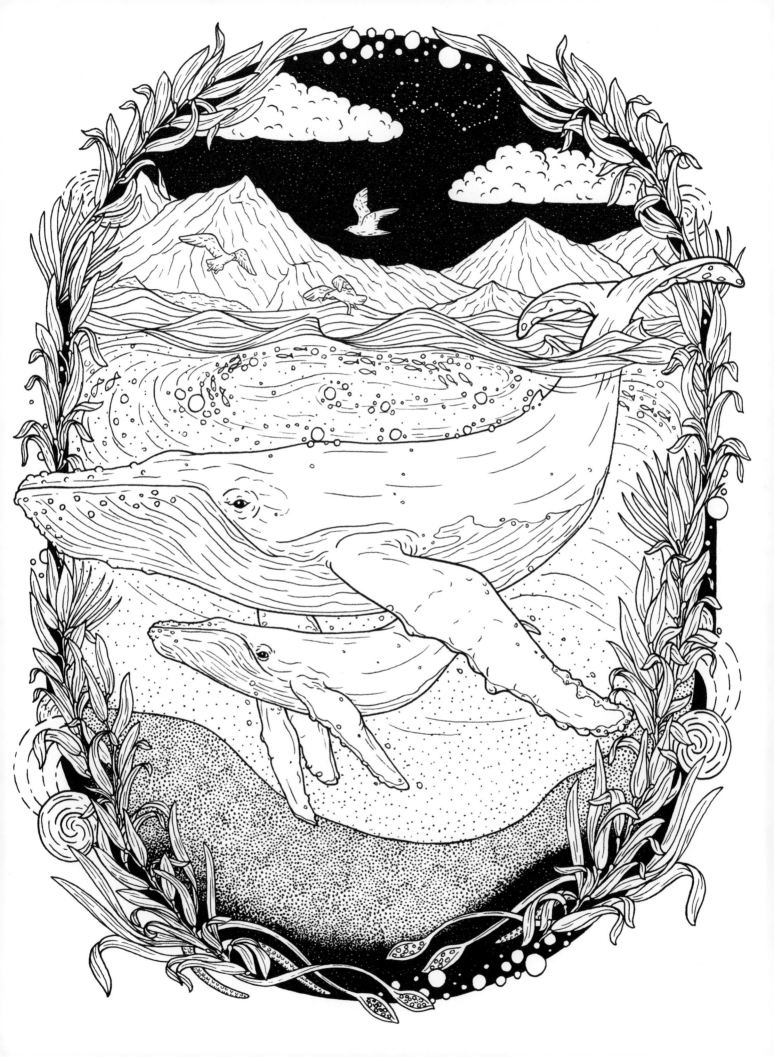

# The Flamingo

With its eye-catching pink coat and long, elegant neck, the flamingo is a creature of bold and striking beauty. Born fuzzy and grey, flamingo chicks take time to blossom into their adult selves. They serve as a reminder that there's hidden potential in all of us, waiting to be realized.

A group of flamingos is called a flamboyance – and you can see why. With a desire for companionship, flamingos gather in their thousands. They display elaborate courtship dances, twisting and marching in unison and with their preening postures remind us that it's fine to 'fake it 'til you make it' in the confidence stakes. Associated with extravagance and romance, those who connect with the flamingo may be prone to passionate, grand gestures.

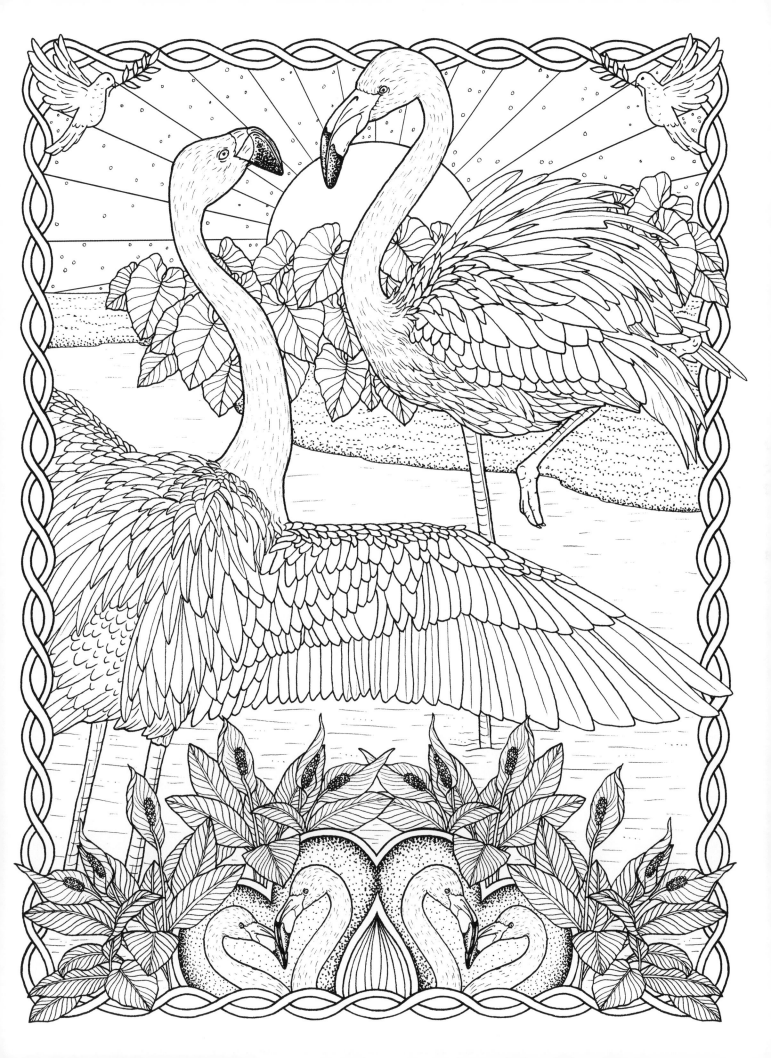

# The Moth

The Luna moth – which gets its name from its moon-like markings –
is a creature of the night, connected to the Moon and feminine energy.
Its luminous-green papery wings give it an ethereal beauty. Those who
connect with the moth may be highly intuitive, good at listening
and receptive to new ideas.

Like its botanical equivalent, the moonflower, the moth can serve as a
lucky charm and a symbol of growth and personal development. In Celtic
and Gaelic tradition, moths were seen as the souls of ancestors; the moth's
perpetual quest to find light was seen as the soul's search for wisdom.

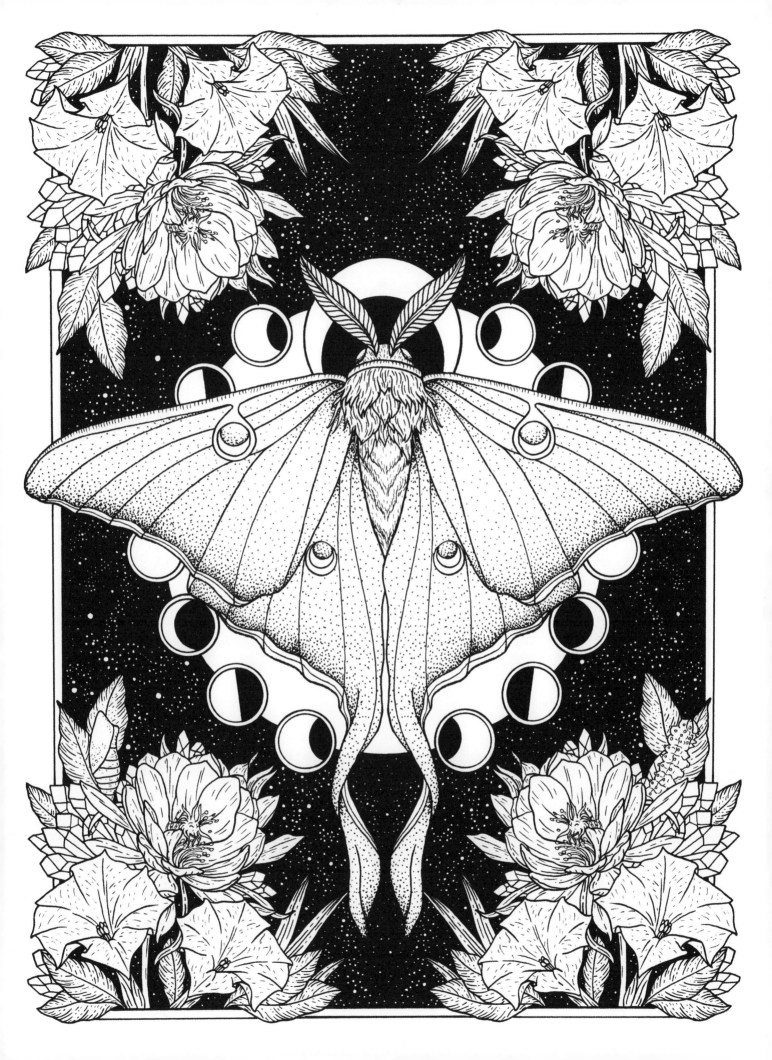

# The Swan

The graceful swan is a storyteller's muse, providing inspiration for ancient mythology and folklore. Tales of love and unity reflect the swan's loyalty and commitment to its mate. It forms strong bonds, building a nest with its life-long partner and raising a clutch of chicks every year.

With the swan in mind, we are reminded to cherish the relationships that are mutually rewarding. To open yourself up to love means to love fiercely and fearlessly. Just as the grey cygnet transforms into a splendid swan, opening your heart to the people around you allows your true self to shine.

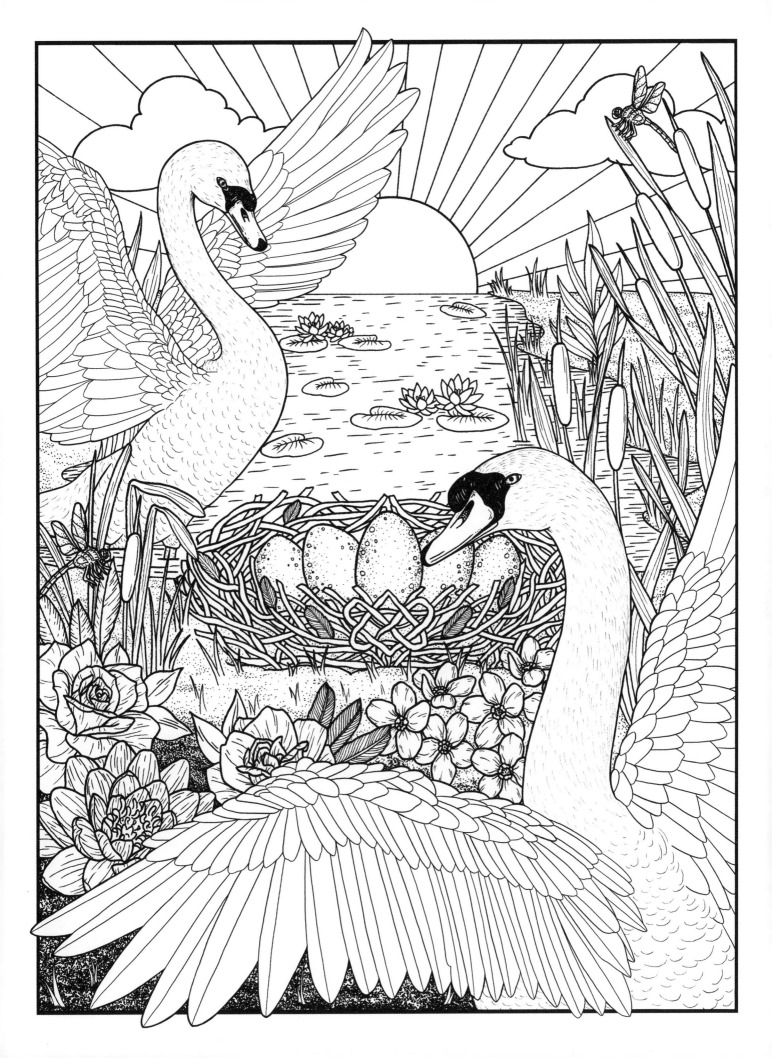

# The Bat

Bats have existed for around 50 million years – far longer than humans – and are the only mammal able to fly. Because of their association with darkness, a strong connection to the bat suggests you may need help to confront your inner fears in order to find greater power and spiritual connection.

Many bats are highly attuned to their environment and use echolocation to navigate. Those drawn to the bat may be sensitive to the world around them and able to use intuition to guide them. While they may often choose to remain quiet, their perceptiveness is second-to-none.

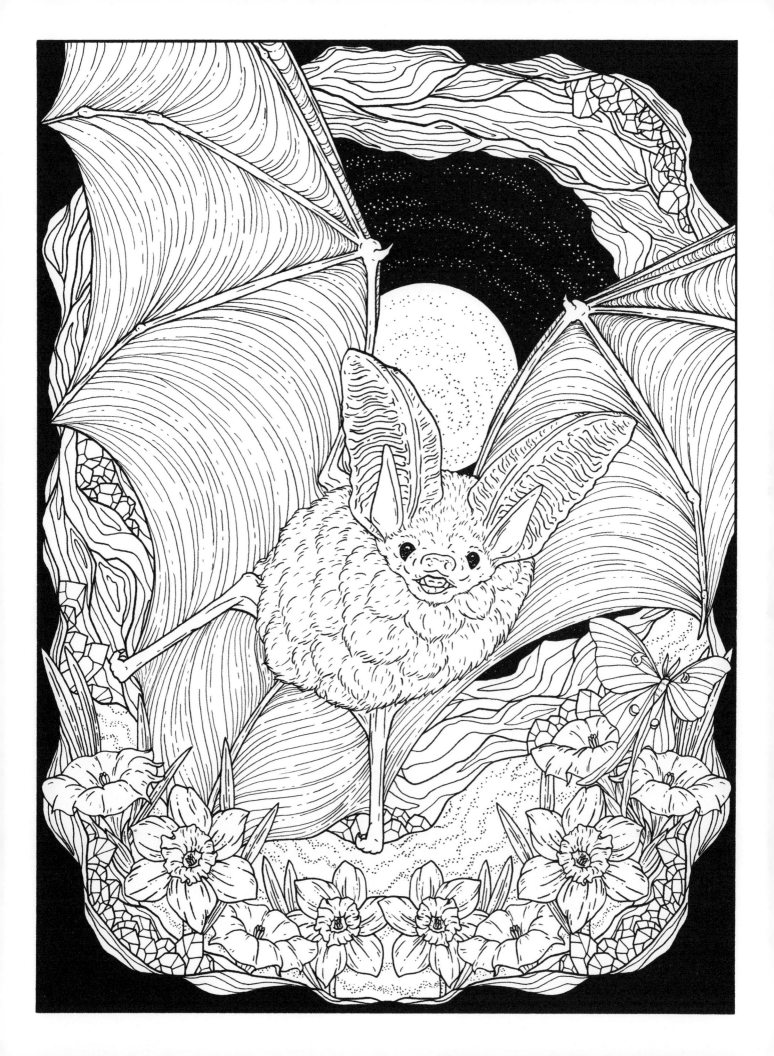

# The Dolphin

As with many water creatures, dolphins are associated with emotional and spiritual wisdom. With countless stories of dolphins rescuing people stranded at sea, they are also seen as symbols of guidance and protection. The dolphin prompts us to live hopefully, trusting that all is as it should be.

Living in tight-knit groups, called pods, dolphins communicate through clicks and whistles, and are incredibly sensitive to each other. As highly sociable animals, dolphins remind us of the importance of collaboration, particularly in pursuit of a common goal. This fun-loving creature flips and dives purely for the entertainment of their pod, encouraging us to embrace an extrovert side and spend time alongside others with shared interests.

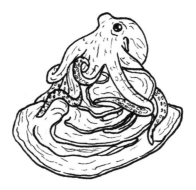

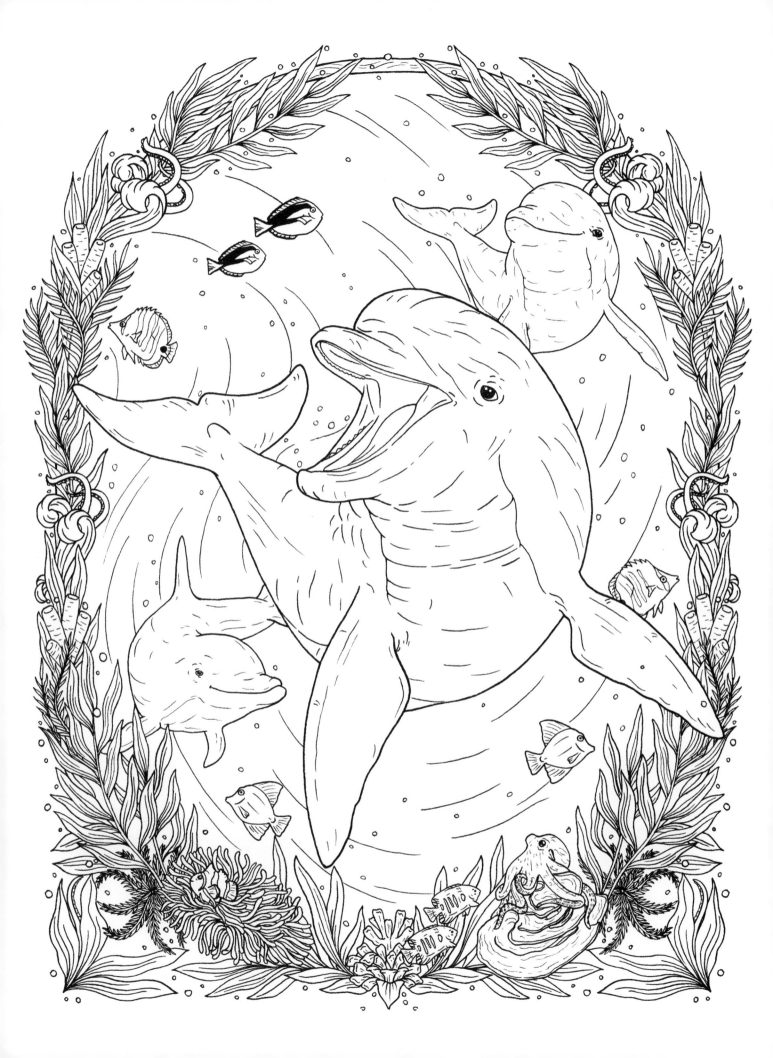

# The Cardinal

With its startling red plumage and talent for singing, the cardinal enjoys the limelight. It has at least 28 different tunes, and male and female birds sing together, mimicking each other in turn. As a social bird that mates for life, the cardinal is a symbol of friendship, meaningful connections, love and devotion.

Those who identify with the cardinal may be similarly loyal, enjoying stable, supportive relationships. They may be home birds that love to nest with their nearest and dearest. That said, the bold cardinal likes to make an impression and enjoys socializing with birds outside its own species. It encourages us to step beyond our comfort zone in order to broaden our life experiences.

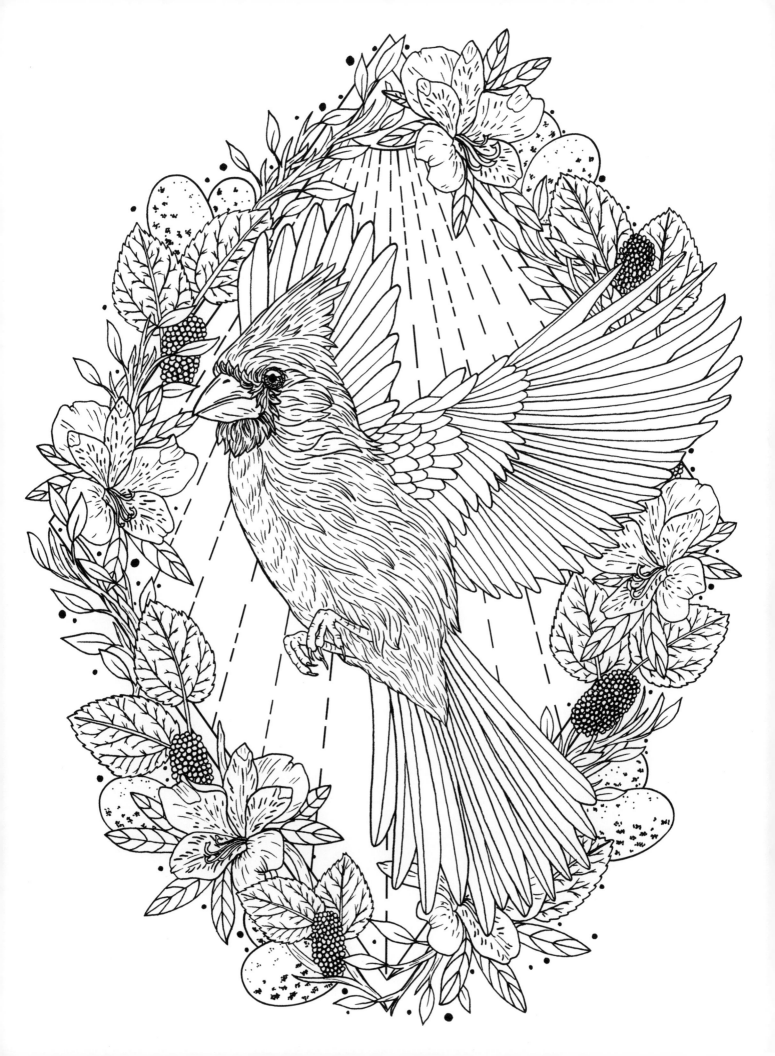

# The Fish

Living underwater – an entirely different realm to our own – the fish reminds us of life's many mysteries. It is a symbol of wisdom and deeper understanding. Those who feel an affinity with the fish may be on a quest for knowledge, living in awe of nature and how little we really understand.

Linked to the sign of Pisces in western astrology, fish are associated with freedom, creative flow and moving forward. For those who feel stuck in an unrewarding position, the fish serves as a reminder that even the smallest action can kickstart big change. In many Asian cultures, the fish represents good fortune, and is offered to a couple on their wedding day as an emblem of lifelong devotion.

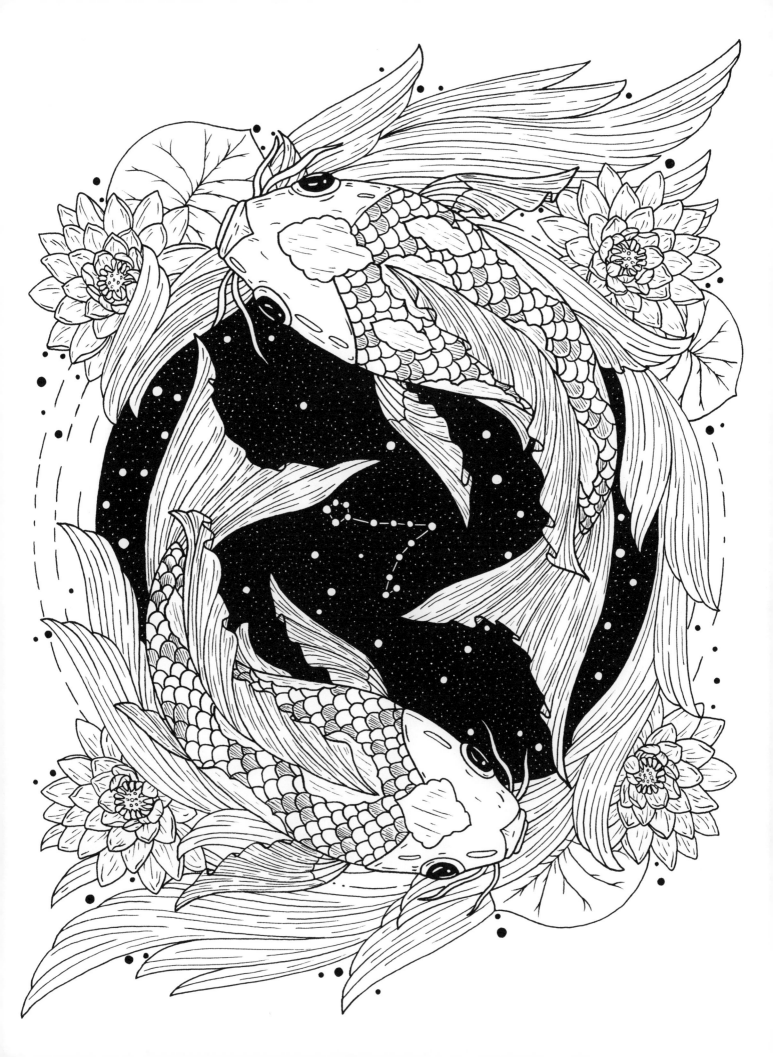

# The Gecko

The gecko is a master of disguise, disappearing into its surroundings and rendering itself almost invisible. It can climb nearly any surface and shed its tail to escape a predator's jaws. This one-of-a-kind creature is associated with resilience and flexibility, adapting to situations in the blink of an eye.

For those in need of a fresh start, the gecko is a symbol of renewal and transformation. It serves as a reminder that we too can let go of old patterns and behaviours, just as the gecko sheds its old skin, and welcome in new beginnings. The gecko is also associated with cleansing and healing, and is considered a lucky omen in many cultures.

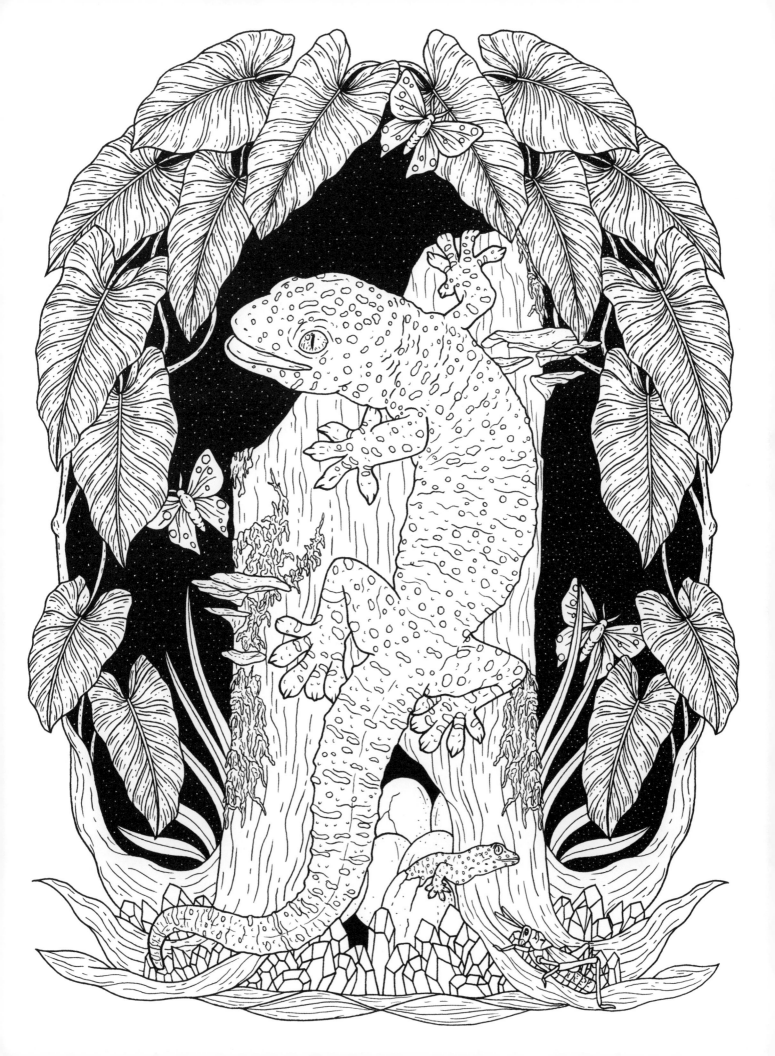

# The Octopus

Living in the murky and mysterious depths of the sea, the octopus can be an unsettling reminder of all the things we do not know or would prefer not to acknowledge. Rather than shrink away from these fears, it encourages us to face them head on and find a solution that best suits us.

Those who connect with the octopus may be good at grasping opportunities, using their problem-solving skills to calmly navigate obstacles. If a situation doesn't suit it, the versatile octopus adapts with ease, or – where necessary – escapes with grace. It reminds us that we have the skills and freedom of thought to create the life we want.

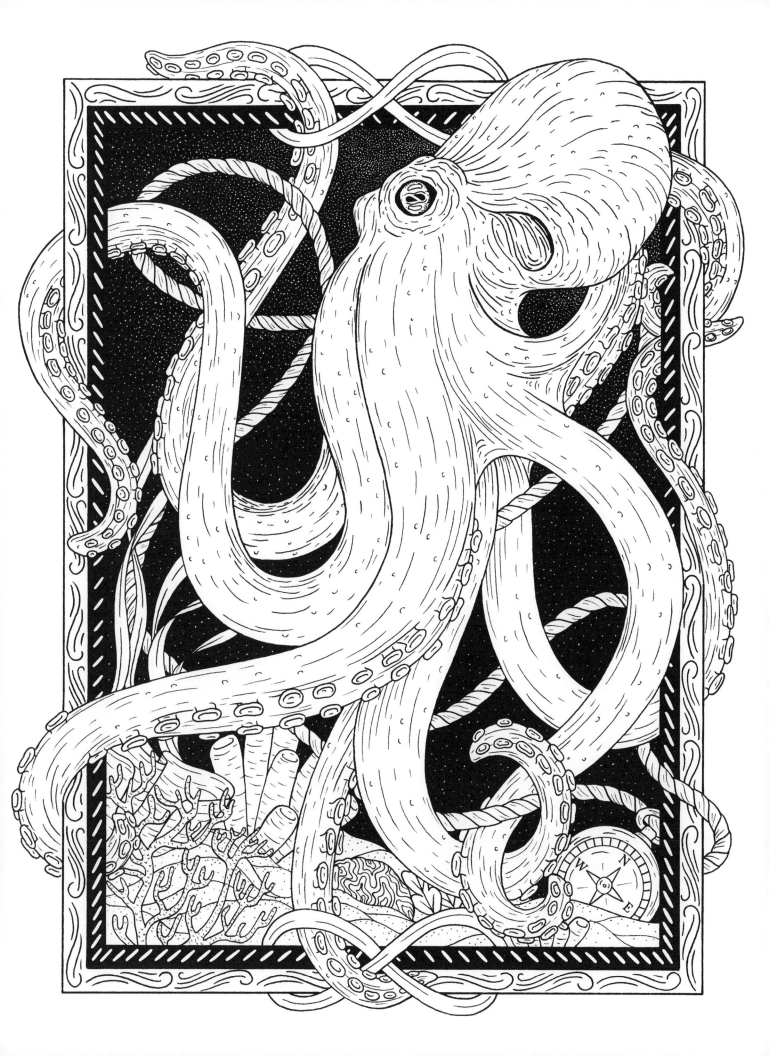

# The Red Panda

With its bushy tail, ruddy coat and fluffy paws, the red panda is perfectly adapted to its snowy treetop home in the Himalayas. It spends its entire life here, reminding us of the benefits of living simply and connecting with nature. Just like the bamboo plant, the red panda is a symbol of stability and inner calm, content in the present moment.

This peaceful creature happily keeps its own company and is seen as an emblem of individuality, self-reflection and finding your own path. It prompts us to take responsibility for our decisions and be true to ourselves. For those who always put others first, the red panda is a reminder to also care for and restore your own energy reserves.

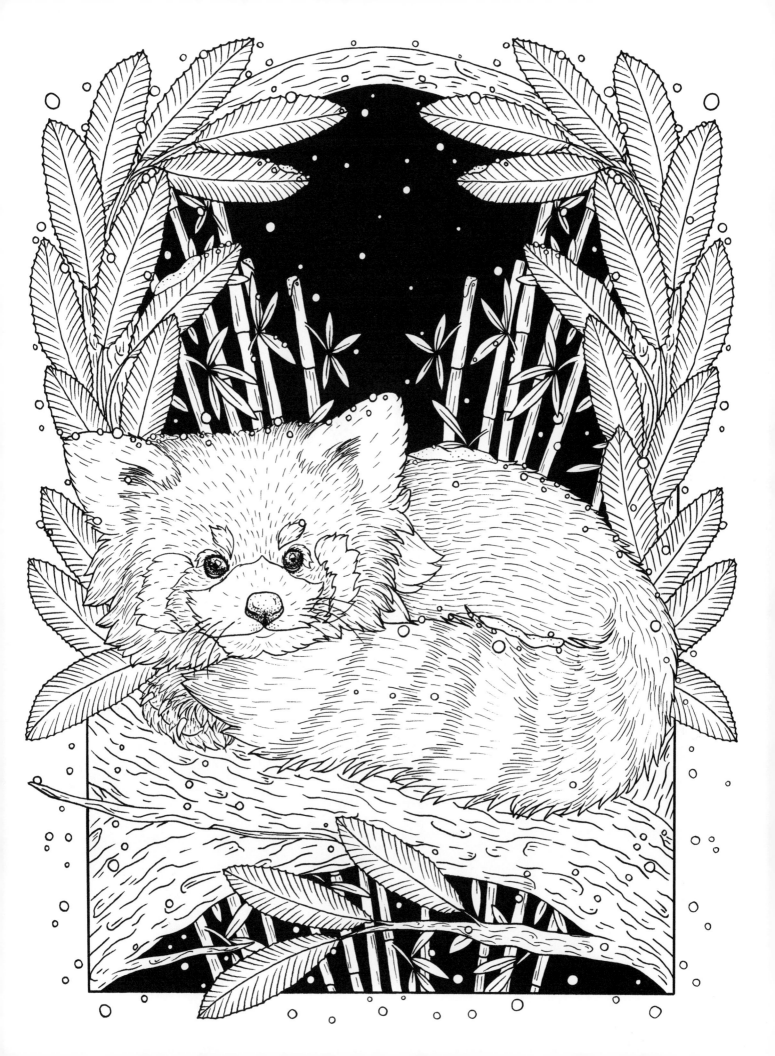

# The Crane

Pairs of courting cranes are known for their flamboyant dances,
which have inspired art, music and dance around the world. These elegant
birds have particular significance across Asia, where they are seen as
divine messengers, and symbols of health, happiness and prosperity.

Known for their ability to live harmoniously together, cranes represent
unity and companionship. During flight, they work as a close-knit team,
flying in an ordered 'V' formation. A person drawn to the crane might
thrive as part of a well-established structure, in which everyone
knows their place and what is expected of them.

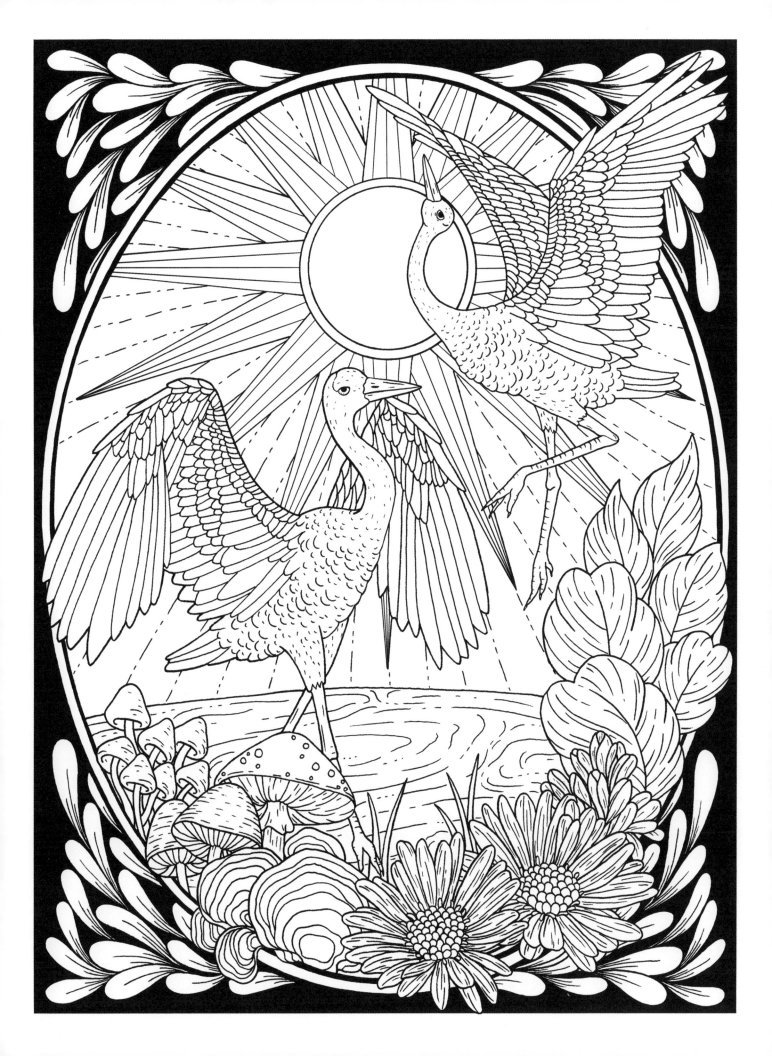

# The Crocodile

Crocodiles have existed on this planet for over 80 million years and can live to be 100 years old. As such, they are associated with ancient wisdom and primal knowledge. Crocodiles are highly adaptable, able to live in saltwater and freshwater, and can even swim long distances at sea. They are symbolic of pushing boundaries and going after your wildest dreams.

As a ferocious creature that isn't afraid to use its strength, the crocodile is an intimidating force. Those who feel an affinity with the crocodile may be direct and commanding leaders. Visualizing the self-assured traits of the crocodile when faced with challenging situations can be an empowering practice.

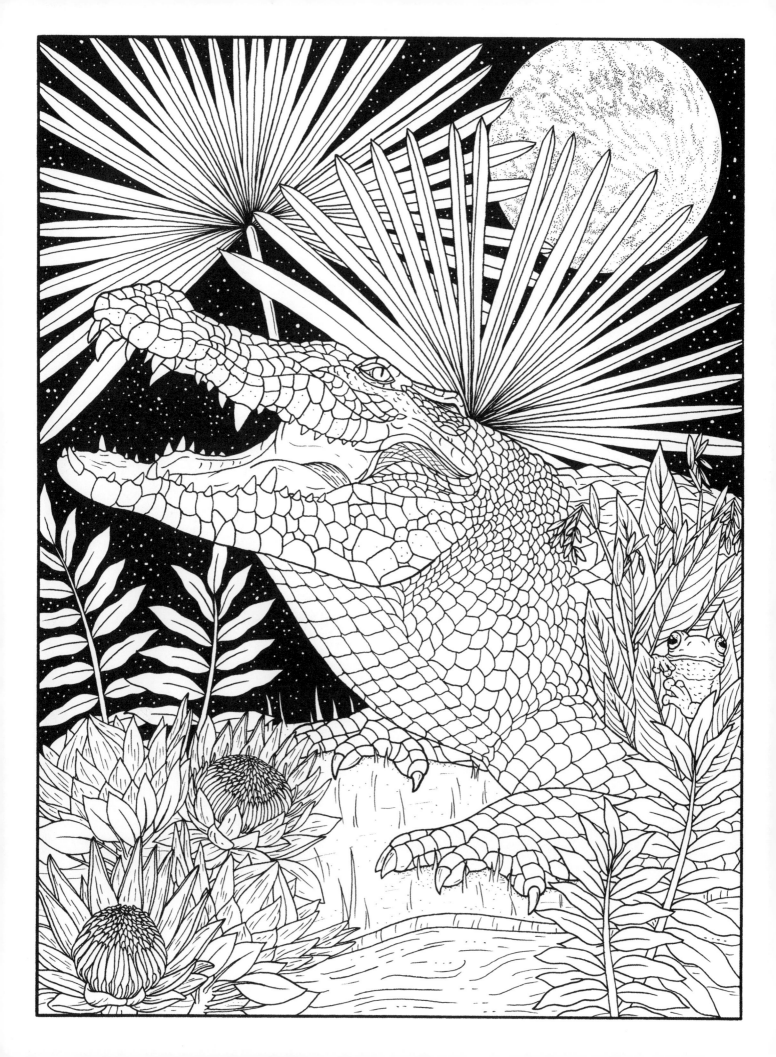

# The Jaguar

The jaguar is an apex predator – a creature of stealth, graceful force and control. It is a symbol of tapping into your personal strength, particularly in relation to protecting your values and boundaries.

Ancient Mesoamericans and South Americans saw the jaguar as a symbol of abundance, fertility and connection to the forces of nature. For those looking to start a new project or relationship, the jaguar is a positive omen. However, the jaguar's measured manner reminds us not to rush into impulsive decisions – the most successful endeavours require time and patience to evolve.

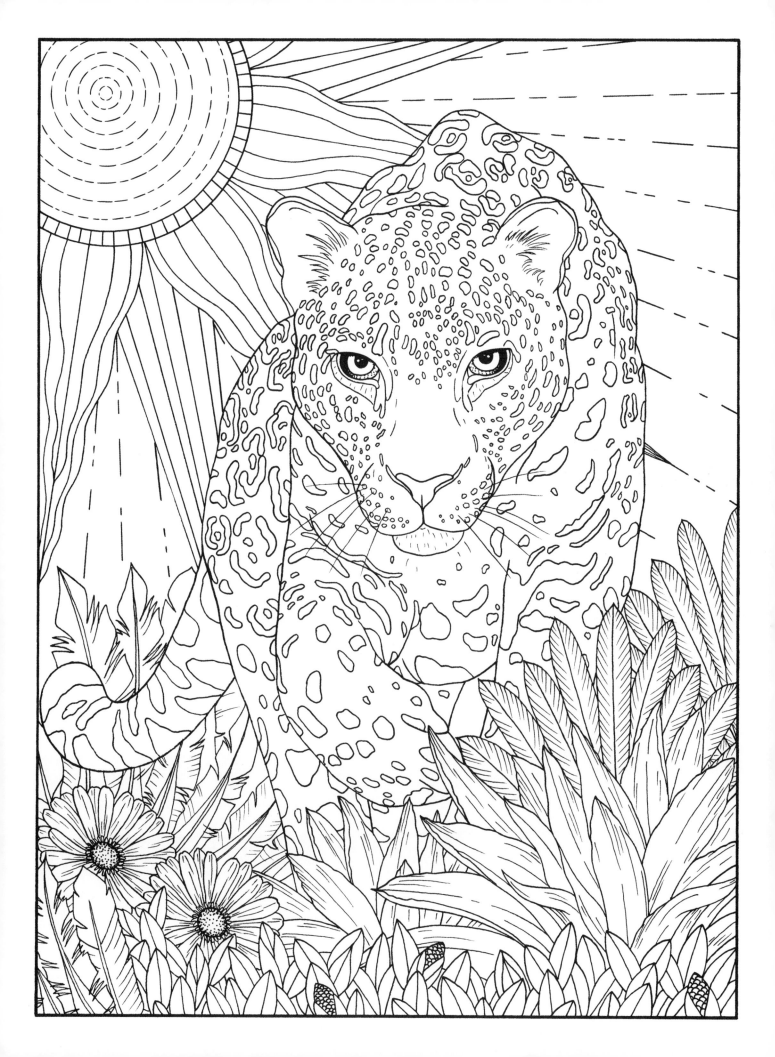

# The Turtle

Sea turtles are said to possess ancient wisdom passed down
through generations. One of the oldest species on Earth, sea turtles
are perceived as old souls with a deep understanding of life.

With a tough outer shell to protect it, the sea turtle is built to
be resilient. Those who feel an affinity with this hardy creature
may be similarly perseverant, committed to what they believe in
and able to take criticism lightly. With its easygoing approach
to life, gliding along with the current, the tranquil turtle
reminds us that life's all about the journey, after all.

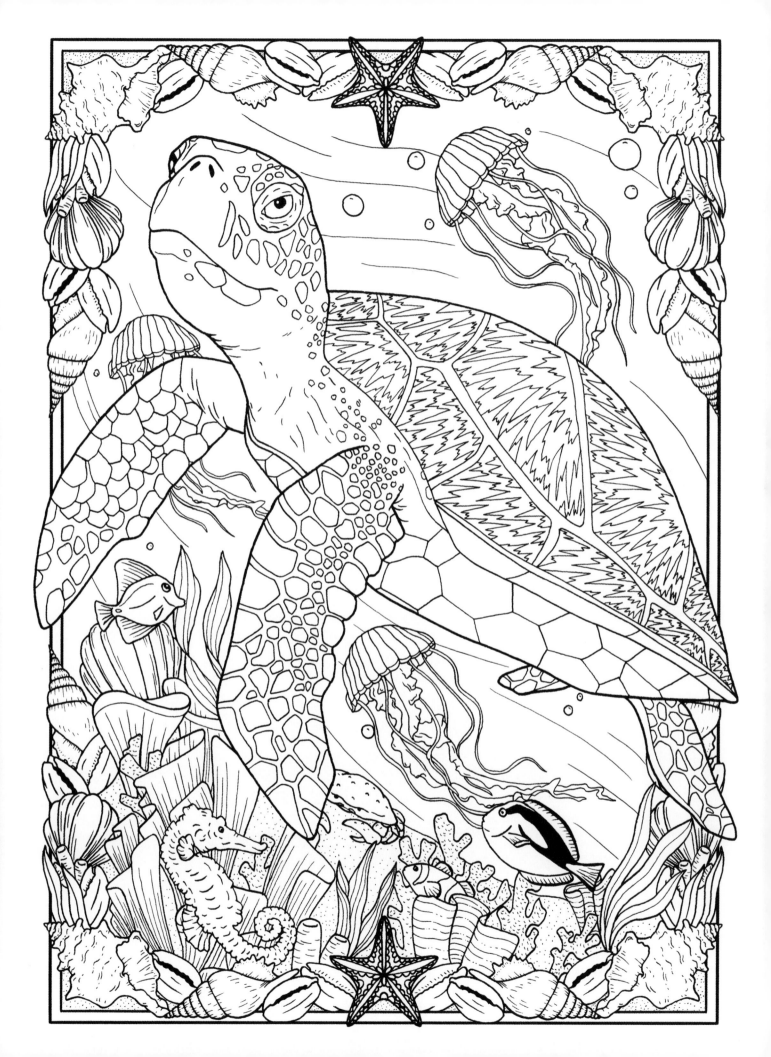

# The Peacock

The peacock is the epitome of beauty. Yet it isn't born this way; a simple unadorned peachick transforms into a striking adult bird. With its tufted crown-like crest, the peacock is associated with nobility and greatness. Just as the lotus flower represents spiritual growth, so the peacock is a symbol of personal growth, of self-discovery and building the confidence to reveal your true self to others.

The peacock is the national bird of India. It is associated with many Hindu deities, most commonly Lakshmi, the goddess of wealth and prosperity, and as such can be a powerful ally in any quest for success. A creature that has the impulse to dance, often doing so in the rain, reminds us of the beauty, joy and celebration in life.

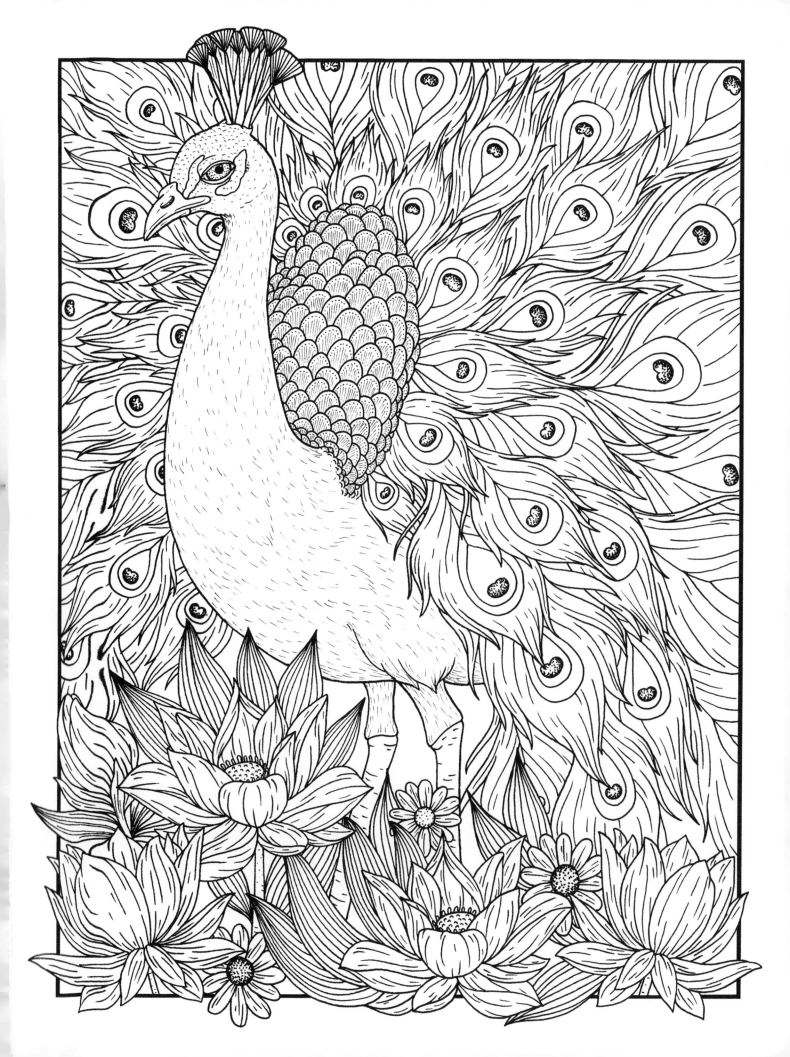

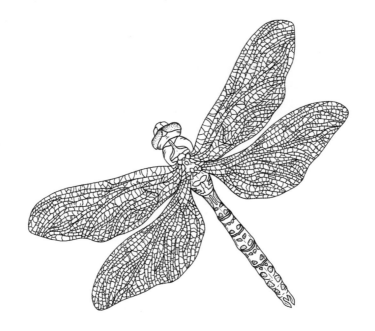